Werner Schmalenbach

Paul Klee

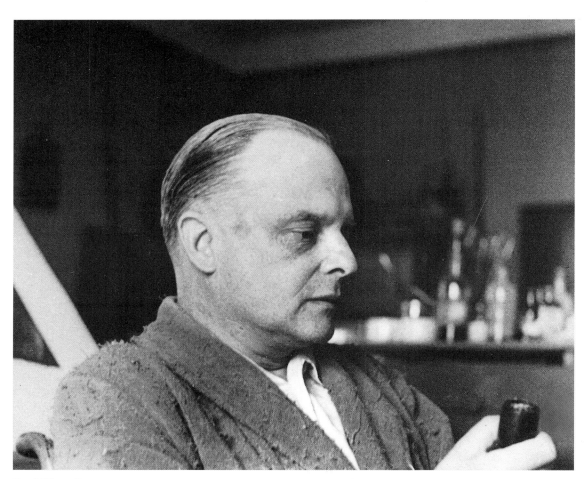

Paul Klee. Berne, 1935

Werner Schmalenbach

Paul Klee

The Düsseldorf Collection

Distributed by

te Neues Publishing Company
15 East 76 Street
New York NY 10021
212-288 02 65

Prestel-Verlag

Translated from the German by Michael Foster

Distributed in the U.S.A. and Canada by
te Neues Publishing Company,
15 East 76 Street, New York, N. Y. 10021

Distributed in the United Kingdom, Ireland
and the Commonwealth (except Canada) by
Lund Humphries Publishers Ltd.
124 Wigmore Street, London W1H 9FE

Typesetting: Fertigsatz GmbH, Munich, using ›Meridien‹
by D. Stempel & Co., Frankfurt on Main
Printing and binding: Passavia GmbH, Passau
Printed in Germany

ISBN 3 7913 0794 0

Foreword

For more than twenty-five years Düsseldorf has possessed one of the largest public collections of works by Paul Klee. In 1960 the federal state of North Rhine-Westphalia acquired eighty-eight works by Klee from the famous G. David Thompson Collection in Pittsburgh. With this spectacular purchase the state government paid tribute to an artist who had taught at the Düsseldorf Academy of Art from 1931 until the Nazis' accession to power in 1933, when he left Düsseldorf and emigrated to Switzerland. The acquisition thus sought to make amends for the injustice visited upon a great European painter.

The collection consisted of fifty-two paintings, thirty-five drawings and one work on glass. A further four pictures were acquired in subsequent years: the glass painting *Portrait of Frau von Sinner* (1906), the watercolours *Red and White Domes* and *Remembrance of a Garden* (both 1914) and the painting *Camel in a Rhythmic Wooded Landscape* (1920).

A year after purchasing the Klee works, the state government set up a museum for twentieth-century painting with the name Kunstsammlung Nordrhein-Westfalen. It began collecting in the autumn of 1962 and rapidly became a major museum of modern art. For more than twenty years it was housed provisionally in a late baroque town palace. From the outset the premises were too small, so that only a part of the steadily growing collection could be shown to the public. The Klee works, too, were deposited in the reserve collection, when not travelling around the world. Between 1966 und 1985 they were exhibited in forty towns in Europe, the Americas and Asia. The Kunstsammlung Nordrhein-Westfalen moved into a new building in the centre of Düsseldorf in March 1986, and the Klee collection could at last be put on permanent display.

The present book includes every work in the Düsseldorf Klee collection and none outside of it. This means that the etchings which mark Klee's beginnings as an artist are not illustrated and that certain aspects of the painter's art are not covered. Nevertheless, the development of that art over a period of three decades can be followed in all its

various stages. All coloured works in the collection are reproduced in colour, the drawings in black and white. The text accompanying the illustrations provides a chronological commentary on the paintings and drawings from 1906 to 1939. A year later, in 1940, Klee died in Berne, seven years after emigrating from Germany. His father was German, his mother Swiss. He himself died a German citizen, although he remained deeply attached to his home town of Berne and used its characteristic idiom all his life. In fact, he saw himself as belonging to two countries: Germany and Switzerland.

July 1986 Werner Schmalenbach

Klee's Life

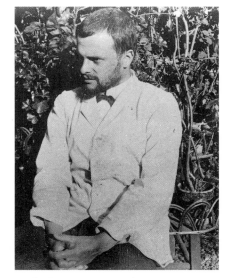

Paul Klee. Berne, October 1908

Photographs of Paul Klee
by courtesy of the Bildarchiv Paul Klee

1879 Born at Münchenbuchsee near Berne on 18 December. His father, Hans Klee, came from Germany and taught music at the State College of Education at Hofwil near Berne. His mother, Ida Maria, née Frick, was born a Swiss citizen in Besançon and trained as a singer at Stuttgart Conservatory.

1880 The Klee family moves to Berne.

1886-98 Attends school in Berne.
Learns violin, later becoming a member of the Berne Municipal Orchestra.

1898 Passes school-leaving examinations in Berne.

1898-1901 In Munich.
Studies painting in Heinrich Knirr's class and, from autumn 1900, with Frank von Stuck at the Academy.

1899 Spends summer at Burghausen. Learns etching from Walter Ziegler. Makes acquaintance of the pianist Lily Stumpf, born 1876 in Munich.

1901-02 Travels to Italy with Hermann Haller, staying in Milan, Genoa, Leghorn, Pisa, Rome, Naples and Florence.
Spends winter in Rome.

1902-06 In Berne.

1903-05 Series of grotesque etchings.

1904 Visits Munich. Studies Beardsley, Blake, Goya and others in the Print Room.

1905 Travels to Paris with Hans Bloesch and Louis Moilliet. Visits the Louvre and the Musée Luxembourg. First glass paintings (continued until 1912).

1906 Travels to Berlin. Visits the Exhibition of the Century and the Berlin museums. Returns via Kassel (Rembrandt), Frankfurt on Main (Städel Museum) and Karlsruhe (Grünewald). Exhibits etchings at the Munich Secession. Marries Lily Stumpf.
Moves to Munich in October.

1906-16 In Munich.

1907 Birth of his son Felix.

1908-09	Exhibits at the Munich and Berlin Secessions and at the Crystal Palace, Munich.
1910	First exhibition (56 works) at the Berne Kunstmuseum, subsequently shown in Zurich, Winterthur and Basel (the following year).
1911	First exhibition of drawings at the Thannhauser Gallery, Munich.
	Makes acquaintance of Kandinsky, Macke, Marc, Kubin and the other 'Blue Rider' artists.
	Starts illustrating Voltaire's *Candide* (published in 1920).
1912	Exhibits graphic works at the second 'Blue Rider' exhibition at the Goltz Gallery, Munich, and participates in the *Sonderbund* exhibition in Cologne. Second trip to Paris. Meets Delaunay, Le Fauconnier, Kahnweiler and Uhde. Sees paintings by Picasso, Braque, Matisse and Rousseau.
	Translates Delaunay's essay "La Lumière"; published in *Der Sturm* in 1913.
1913	Exhibition at Herwarth Walden's gallery 'Der Sturm', Berlin (also in 1914). Exhibits at the First German Autumn Salon in Berlin.
	First visit to the Rupf Collection, Berne (Cubist painting) in the summer.
1914	Founds the New Munich Secession with Wilhelm Hausenstein.
	April: Travels to Tunisia with August Macke and Louis Moilliet, staying at Tunis, Saint-Germain, Carthage, Hammamet and Kairuan. Discovers colour. Occupied with Cubism.
1915	Meets Däubler and Rilke.
1916-18	Military service, at first in Landshut, Munich and Schleissheim (airport depot). Accompanies military transports to France. Subsequently stationed near Augsburg.
1916	Exhibition at 'Der Sturm' gallery, Berlin; further exhibitions there in 1917, 1919 and 1920.
1918	*Sturm-Bilderbuch Paul Klee* reproduces 15 drawings by him.
1918-20	In Munich. Occupies studio in Schloss Suresnes, Schwabing, from 1919.
1920	Exhibition of 362 works at Hans Goltz's 'Neue Kunst' Gallery; catalogue appears as special issue of the periodical *Der Ararat*.

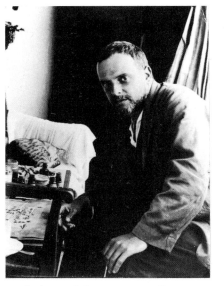

Paul Klee with his cat Tripouille at Possenhofen on Lake Starnberg. Summer 1911 (Photo: Felix Klee)

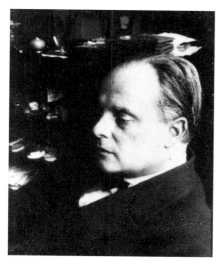

Paul Klee. Dessau, 1922 (Photo: Joseph Albers)

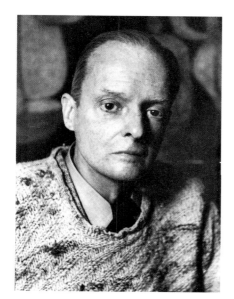

Paul Klee in his studio at Kistlerweg 6, Berne. December 1939 (Photo: pren, Zurich)

Publishes essay "Creative Credo" in *Tribüne der Kunst und Zeit.*

Called to the Bauhaus, Weimar, by Walter Gropius on 25 November.

1921-31 Teaches at the Bauhaus in Weimar and, from 1925, Dessau.

1921 Begins teaching in Weimar; moves there in September.

1922 Exhibition at the Kunstverein, Wiesbaden.

1923 Bauhaus exhibition and large Bauhaus Festival in Weimar.

Exhibition at the Kronprinzen-Palais, Berlin.

"Ways of Studying Nature" appears in *Staatliches Bauhaus in Weimar 1919-1923.*

Spends the summer on the island of Baltrum.

1924 Gives lecture "On Modern Art" at the Kunstverein, Jena.

First Klee exhibition in America (Société Anonyme, New York).

Kandinsky, Feininger, Jawlensky and Klee found the exhibition group 'The Blue Four' in Weimar.

Visits Sicily (Taormina, Mazzaro).

1925 April: Bauhaus moves to Dessau.

First Klee exhibition in Paris (Galerie Vavin-Raspail). Second large exhibition (214 works) at Goltz's gallery in Munich.

Exhibits at the first Surrealist group exhibition in Paris (Galerie Pierre).

Pedagogical Sketchbook published as Bauhaus Book no. 2.

1926 Moves to Dessau in August.

Visits Italy in the summer (Elba, Pisa, Florence, Ravenna).

1927 Spends the summer on the island of Porquerolles in southern France, on Corsica and in Avignon.

1928 Summer trip to Brittany.

"Precise Experiments in the Field of Art" appears in the periodical *Bauhaus.*

1928-29 Visits Egypt from December 1928 to January 1929.

1929 Large exhibition at the Alfred Flechtheim Gallery, Berlin.

Exhibition at the Galerie Bernheim-Jeune, Paris. Visits western France (Carcassonne, Bayonne, Gulf of Gascony).

1930	Summer trip to the Engadine and Viareggio.
	Second exhibition at the Flechtheim Gallery, Berlin; subsequently shown at the Museum of Modern Art, New York.
1931-33	Teaches at the Academy of Art, Düsseldorf (from 1 April 1931) at the invitation of Walter Kaesbach.
1931	Second trip to Sicily.
	Large exhibition (252 works) at the Kunstverein, Düsseldorf.
1932	Summer trips to northern Italy (Venice) and Switzerland.
1933	Moves into Heinrichstrasse 32, Düsseldorf, on 1 May.
	Summer trip to the French Riviera (Saint-Raphael, Port-Cros).
	Dismissed from the Düsseldorf Academy at the end of the summer term.
	Moves to Berne at the end of December.
1934-40	In Berne.
1934	First exhibition in England (Mayor Gallery, London).
	Kahnweiler becomes Klee's agent abroad.
1935	Retrospective exhibition of 294 works at the Kunsthalle, Berne and, subsequently, in Basle.
	First symptoms of scleroderma.
1936	Spends summer in Tarasp and Montana.
	Exhibition at the Kunstmuseum, Lucerne.
1937	Spends summer in Ascona.
	Visited by Picasso, Braque and Kirchner in Berne.
	The 'Degenerate Art' exhibition in Munich includes 17 works by Klee; confiscation of 102 works by him in German public collections.
1938	Spends summer at Beatenberg.
	Exhibitons in New York (Buchholz [Curt Valentin] and Karl Nierendorf Galleries) and in Paris at Kahnweiler's Galerie Simon and at the Galerie Carré.
1939	Spends autumn at Lake Murten near Berne.
1940	Large exhibition of late work at the Kunsthaus, Zurich.
	Dies of heart failure at Muralto-Locarno on 29 June.

Klee started out, not as a painter, but as a graphic artist. When he began painting in the true sense of the word he was already a mature artist with an impressive body of drawings and etchings to his credit. From 1903 to 1905 he had produced a series of fantastically satirical etchings which, while close to the Symbolism and art nouveau prevalent at the turn of the century, reveal personal graphic and expressive interests. These etchings mark his beginnings as an artist. Although his art was to acquire quite different dimensions, drawing always occupied an important position alongside painting. Klee remained a draughtsman all his life. His drawings run parallel to his painted work, often interacting with it.

Boy in Fur Coat (1909; fig. 1), created when Klee had already reached the age of thirty, combines lines drawn as though with an etcher's stylus with loosely painted areas of wash. The fine, precise lines no longer serve to describe individual elements as they had in the early etchings, where every naturalistic detail counted. The sitter faces the beholder in conventional symmetry. Klees tries for expression with a minimum of strokes – yet he does try for it, finding it in the juxtaposition of a face's slightly mad oddity with the softness of the surrounding wash.

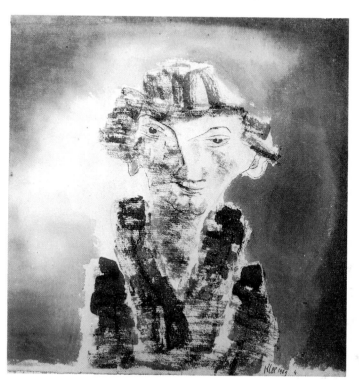

1 *Boy in Fur Coat*, 1909

A year later Klee produced the glass painting *Houses on the Edge of the Wood* (fig. 2). About 1912 Bavarian glass painting became of considerable importance to the 'Blue Rider' artists in Munich, with whom Klee was closely associated. They discovered and were inspired by this folk art. Klee's landscape is so far removed from its expressive world that one wonders why he chose the unconventional technique. Presumably, the greater freedom offered by painting on the smooth surface of glass appealed to him at a time when he still fought shy of working in oil on canvas. All his life Klee was to attach special significance to the material of his picture supports.

The picture is surprisingly non-linear. At about this time Klee noted in his diary: "My line in 1906/07 was all my own. Yet I had to break with it; it was threatening to become cramped in some way The change was indeed particularly drastic. In the summer of 1907 I devoted myself entirely to natural appearances, using these studies as a basis for the black and white glass paintings of 1907/ 08." Among the latter is this coloured landscape with a field in the foreground, occupying more than a third of the picture surface, and houses on the edge of a wood in the distance. Klee was obviously concerned with the problem of perspective, although it irritated him artistically. In the same passage in his diary he declares: "Hardly have I conquered this stage and I find it tedious. Perspective is a real bore."

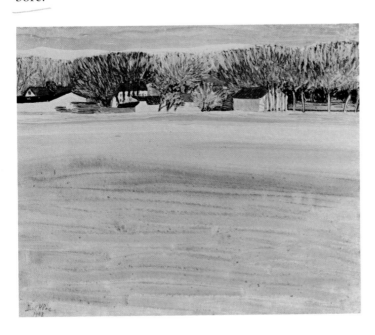

2 *Houses on the Edge of the Wood,* 1908

3 *Portrait of Frau von Sinner,* 1906

In his early years in Berne Klee had often made music in the house of *Frau von Sinner,* on whose portrait (fig. 3) he "worked most dutifully", as his diary records, in the autumn of 1906 for a fee of 600 francs. This, too, is painted on glass. The technique did not give rise to a particular style, for the expressive character of the portrait owes nothing to the stylistic means artists were discovering in the folk art of glass painting. The puzzling anatomy of the sitter's left arm, the contrast between her reddish skin and pale dress, and the sharp-angled edges of her sleeves lend the picture some of the bizarre quality characteristic of Klee's early etchings. Expression is concentrated in the dark eyes and the mouth, producing an extraordinary psychological intensity. To be sure, this is not the 'real' Klee of subsequent years, yet the portrait already shows that strong graphic and expressive power later encountered in so many of his drawings.

In 1912 Klee's trip to Tunisia, during which – as he himself stated – he became a genuine painter, lay two years ahead. Yet in that year he was already drawing an *Oriental City* in pen, ink and wash (fig. 4) – an Orient he did not know but had imagined. This process occurs again and again with Klee: he locates his dreams, giving them a geographical position in a remote 'Orient'. The drawing itself strikes one as dark and nordic rather than exotic. On a ground of loosely painted grey patches Klee places barely identifiable graphic signs denoting houses and trees. The vagueness of the objects and of the subject mat-

4 *Oriental City,* 1912

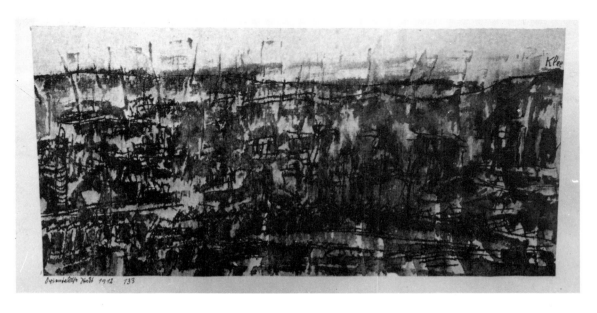

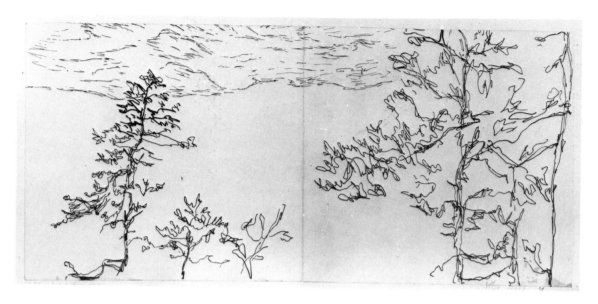

5 *Lake Thun seen from Burning Forest*, 1909

ter does not mean that the sheet is vague artistically. On the contrary, it possesses a distinctive artistic character, determined by the lively interplay of loose patches of wash and the linear formations lurking among them.

Three years earlier Klee had used a completely different graphic handwriting in *Lake Thun seen from Burning Forest* (fig. 5). This points quite clearly to the Klee of later drawings. With the general idea 'tree' in mind, the pen traces a free network of lines. It is not so much the tree which is alive but the pen itself. Obeying its own impulses, it turns hither and thither, now slowly, now quickly. The trees on the shore of the lake are imbued with a graphic temperament of nervous brilliance which, although running its own course, also gives expression to the "rising sap", as Klee noted in 1906. In these trees one encounters that 'genetic' principle later to attain such central significance for Klee: nature – and hence form – is understood as a state of becoming, as a process of continual metamorphosis. Although art nouveau and its conception of line as an autonomous force are still in evidence, they have acquired the unmistakable rhythm and sensibility of a Klee drawing.

Yellow House in the Fields (fig. 6) is again dominated by the juxtaposition of soft colour and precise line, which is also the juxtaposition of repose and movement, of passive area and active line. The picture contains fields, a house, a tree and schematic figures so cipher-like as to border on caricature. Yet its real content is perspective – that which Klee described in his diary as "a real bore". He went on to say: "Should I just distort it [perspective]? Or how shall I construct a bridge between the internal and the external in the freest manner possible?" In other words, perspective as an 'objective' physiological fact left him unsatisfied. He was concerned solely with the question – also occupying the Expressionists – of how to bridge the gap between the inner and outer worlds in the most comprehensive way possible, of how to make nature, and with it perspective, susceptible to his psychic will. A little later Klee would banish perspective completely from his pictures, though time and again he addressed problems of pictorial space. *Yellow House in the Fields* provides an affirmative answer to

6 *Yellow House in the Fields,* 1912

7 *Joseph's Chastity Disturbs the Lower Regions*, 1913

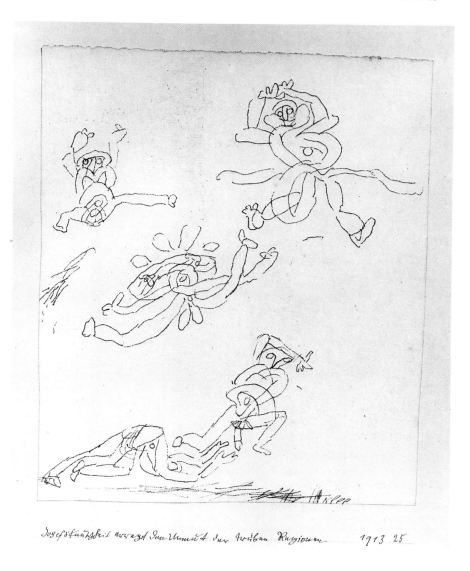

the question of whether he ought to "distort" perspective: the lines wander into the distance without conforming to strict perspective laws.

About 1913 Klee achieved total freedom in his use of graphic means. This is demonstrated by the mocking figures of fun in *Joseph's Chastity Disturbs the Lower Regions* (fig. 7), in which both the delight in graphic invention and the title testify to Klee's sense of humour. It was in the medium of drawing in particular that his wit found a creative outlet, contrasting with the more serious quality of his paintings — although these, too, often include comic scenes.

In 1914 Klee accompanied his fellow painters August Macke and Louis Moilliet on a twelve-day visit to Tunisia. He discovered the 'coloured Cubism' of Moorish towns and he at last discovered colour itself. Shortly after his return he wrote in his diary the oft-quoted sentences: "Colour has me. I no longer need to chase after it. It has me for ever, I know that. That is the meaning of this happy hour: colour and I are one. I am a painter." Decisive in this historic moment in European art was not only the encounter with Northern Africa, but also that with the 'orphic' art of Robert Delaunay, which had introduced pure colour as a symbol of light into the largely monochrome world of Cubism. Klee had visited Delaunay in Paris in 1912 and translated his essay "On Light" into German. The seeds sown in Klee by Orphism bore fruit in front of the Tunisian landscape and its Moorish architecture.

A Tunisian town provided the direct source for the watercolour *Red and White Domes* (fig. 8). The basic construction of the picture consists of a mosaic of not quite regular, not strictly geometric rectangles and squares — an abstract checkerboard. Since the colours live, breathe and pulsate, this grid becomes more than abstract: it takes on a vibrant natural quality, with the lower, warmer zone denoting earth and the upper, cooler one sky. Klee then allows the picture — in the words of his famous Jena lecture of 1924 — to "say yes to representation": he invests the forms with figurative connotations without in the least altering the formal character of the picture.

He has taken leave of perspective, against which he had fought for years. Everything is planar without, however, becoming flat, since the planes retain a certain depth. From now on Klee often divided up his pictures into squares devoid of perspective recession. The squares seldom appear strictly geometric, so that order does not stifle the breath of life. Klee seeks the metrical but avoids the geometrical. These checkerboard pictures sometimes remain purely formal, i. e. abstract, but more often they absorb figurative elements signifying nature or air, water or — as in the present case — the architecture of a Tunisian town. As though referring to this very watercolour, Klee notes at one point: "Have undertaken a synthesis of town architecture and pictorial architecture".

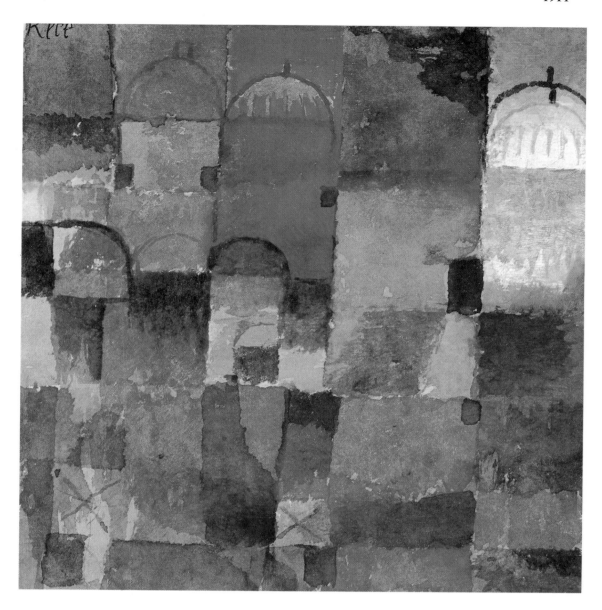

8 *Red and White Domes,* 1914

He also writes that, "like people, a picture has a skeleton, muscles and skin. One may speak of an anatomy peculiar to pictures." At the same time he induces the artist to practise a "dialogue with nature", which means listening to its voices, not simply copying it. Klee's art thus represents a continual interaction between the "dimension of pictorial elements, such as line, light and shade, and colour" and the "dimension of the object". Neither form nor content has the final say, yet the former is usually such that it fosters "saying yes to representation".

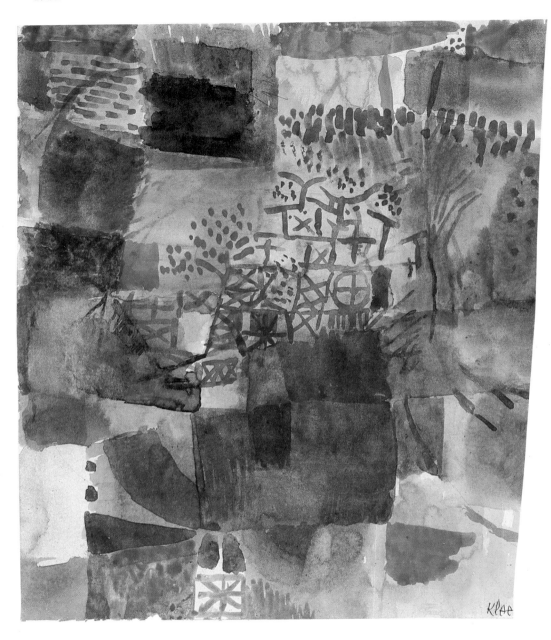

9 *Remembrance of a Garden*, 1914

Compared to the almost geometric severity of *Red and White Domes*, the composition of the watercolour *Remembrance of a Garden* (fig. 9), from the same year, appears less strict. Yet here, too, the basic geometric construction is unmistakable. The greater freedom from pictorial regularity may be due to the motif: a piece of nature, albeit tamed by human hand. Division into areas of beds and plants accounts for a certain order in the garden. The picture consists partly of highly irregular rectangles, with no par-

ticular horizontal or vertical emphasis, and partly of 'growing' plants, among them a tree with branches. Some areas are flat, although transparent and coloured in several layers, others contain detailed forms and free strokes of the brush.

During his stay in Tunisia Klee lived for a time in a house with a luxuriant garden. This is most likely the one recalled in the watercolour. The title states that the picture depicts a remembrance, not a garden. Accordingly, the goal was not precise representation but rather – over and above the artistic motivation – figurative vagueness: more or less rectangular areas rather than beds, plant-like forms rather than actual plants and an impression of nature rather than nature itself.

The idea of towns accompanied Klee's art for a long time. That is understandable, since he must have regarded them as places governed by laws yet organic, as places of order yet subject to chance and simply as configurations of free rhythm. In the drawing *City with Graduated Fountain* (fig. 10) he piles small, more or less geometric or stereometric forms on top of one another, making them into walls, roofs and gateways. The result is a balancing act reminiscent of a house of cards. Fountain water falls down over steps on the right. Although the picture may constitute a vision of a Mediterranean town, it is principally a playful up-and-down of lines. Klee relishes the independent life of his lines to the point of scribbling and what he liked to call his "bowing and scraping". The present drawing still lies under the influence of the previous year's visit to Tunisia.

Like the Moorish townscape of 1914, *Brown Triangle Striving at Right-angles* (fig. 11), created the following year, is a watercolour. On 'discovering' colour, Klee first produced a large number of watercolours, not turning to oil painting until after the war. It was natural for him to allow his media an important share in artistic results, as he let himself be inspired directly by a particular technique. Klee's artistic sensibility undoubtedly found an especially congenial outlet in the fluidity and translucence of watercolour. The luminosity of its colours and their breathing, flowing character accorded with his preference for the living, indeterminate and unresolved. Later, he tried to realize these qualities in oils; but all his life he continued to paint watercolours.

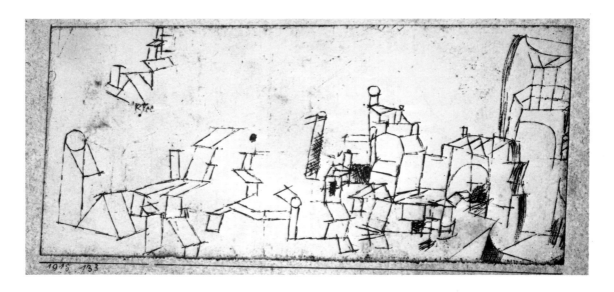

The word "striving" in the title of the present picture points to a deviation from strict geometry, introducing an active element of dynamism into the geometric conception. To be sure, the picture is constructed from rectangles but, quite apart from being irregular, they "strive" upwards. The acute triangle is itself hardly geometric and might even be interpreted as a spire. Klee does not indicate an underlying theme. All the same, he was obviously concerned not simply with rectangles and a triangle, but with nature – perhaps with a church tower and, in particular, with light. This is an 'orphic' picture in the wake of Delaunay.

It is characteristic of Klee that the relationship between form and content does not remain consistent but varies from work to work. This distinguishes him from almost every other artist of the twentieth century. His oeuvre encompasses both abstraction and a high degree of naturalism. Intuition determines the part played by each in the course of work. The one always interacts with the other.

After his trip to Tunisia and, above all, after the war Klee was consumed with a passion for painting, whether in oil or watercolour. Nevertheless, this occupation with colour did not put a stop to his drawing. It is noticeable that he gave much freer reign to the anecdotal, to story-telling and to the comic in his drawings than in the stricter, more serious business of painting. *With the Dragon's Bite* (1919; fig. 12) is a case in point. As a draughtsman Klee reports

11 *Brown Triangle Striving at Right-angles,* 1915

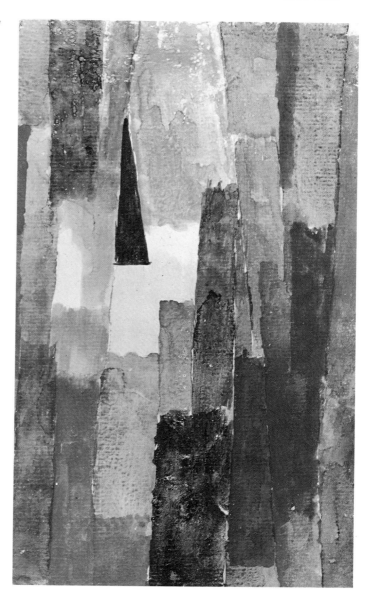

on events. He is concerned less with pictorial laws than with depicting appearances and happenings, even if completely fictional – which most of them are. In this drawing, for example, a man has been dragged down into the water by a dragon-shaped fish with a beak-like mouth. Klee's humour is sometimes 'black', by all means disagreeable and satanic. Yet the poetry of his invention and the fluency of his graphic imagination usually present him in a conciliatory light.

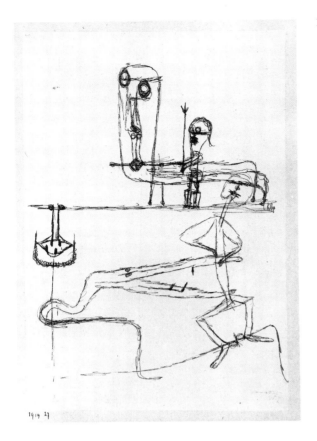

On returning from the war Klee painted a series of pictures with 'cosmic' subjects. He developed a vaguely religious natural philosophy, according to which all earthly things are the emanation and expression of an encompassing being. He was not alone in his generation in this way of thinking. Such thoughts were formulated and given shape by his 'Blue Rider' friends, Wassily Kandinsky and Franz Marc. Klee stated: "Art is an analogy of Creation. It is but one example, just as the terrestrial is an example of the cosmos." One is very close to a picture like *Cosmic Composition* (1919; fig. 13) when one reads: "I take hold of a remote point at the origin of Creation, where I anticipate formulae for humans, animals, plants, rocks, earth, fire, water, air and all circling forces at once." This sentence comes from Klee's *Creative Credo* of 1919, in which he formulated his artistic beliefs. The idea of a cosmic law governing all earthly things refers back to the 'Universal One' of German Romanticism. Klee saw himself continuing this tradition, as represented by the painters Caspar David Friedrich and Philipp Otto Runge, the poet Novalis and the poet-philospher Carl Gustav Carus.

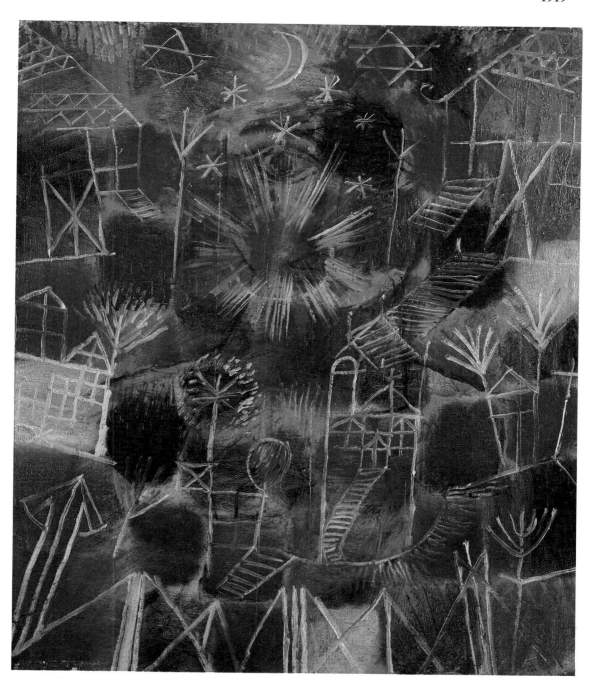

13 *Cosmic Composition*, 1919

Soon he was to relinquish the Romanticism of his early years, but he never abandoned some of its tenets. The same Romanticism lay at the root of the work of some other 'Blue Rider' artists, especially that of Marc and Kandinsky.

Cosmic Composition is easily understood. The sun shines in the middle. Above it, the crescent moon and stars of various sizes are scratched into the coloured ground, while houses, steps and trees – also reduced to linear signs – cluster around it. The effect of space is produced directly by the colours and owes little to three-dimensional perspective. One discerns an eye at the back of this glowing cosmic realm: standing behind things and above Creation, it symbolizes the force governing the cosmos. This same eye occurs in other paintings by Klee from this period. The picture also shows how Klee has now succeeded in imparting life, fluidity and transparency to oil colours as well.

At about this time Klee starts reducing objects to the simplest of signs. Unlike those in his later work, these signs are not semantic in character: they do not possess a perceptible yet indefinable meaning. As a rule, they still denote objects – stars, plants, architecture – in a 'naive' fashion. The resulting forms closely resemble those in children's drawings, not only in their cipher-like simplicity but also in their apparent – in reality, quite conscious – awkwardness. Klee belonged to those artists who delighted in the charm of children's drawings, but he was the only one of his generation who allowed his art to be influenced so directly by them.

Camel in a Rhythmic Wooded Landscape (fig. 14), from the following year, is also an oil painting. As so often with Klee, the picture plane is divided up into coloured rectangles, this time with a strong horizontal emphasis. Circles on vertical shafts appear within this basic structure. The vertical supports immediately suggest trees and thus nature and landscape. But the position of the 'trees' between the lines also suggests musical notation and, hence, rhythm. Together, these two allusions produce what the title calls a "rhythmic wooded landscape". Triangular forms in the middle indicate the humps and ears of a camel striding along on thin legs. The camel as a living creature is only hinted at: it is principally a formal organism, since not the camel but, of course, the picture is alive.

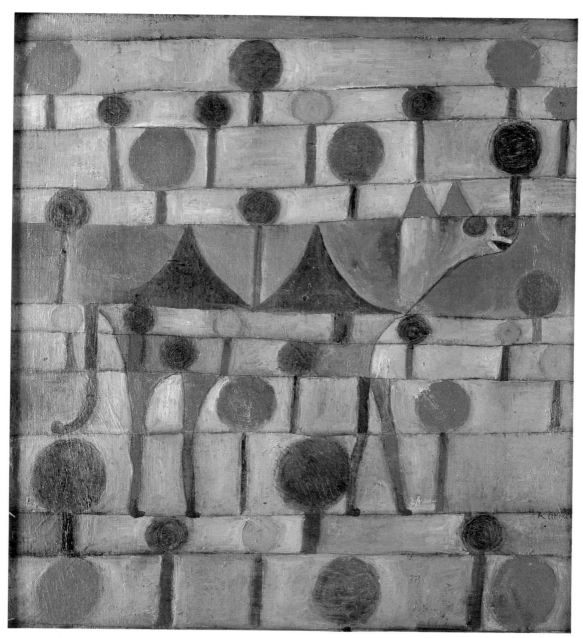

14 *Camel in a Rhythmic Wooded Landscape,* 1920

Similar circles occur in *Feather Plant* from the previous year (fig. 15). Here, they signify buds, blossoms, fruits or the markings of a feather. Circles appear in other pictures by Klee; they have to be interpreted anew in the case of each work and its subject matter. Since the flat shapes in *Feather Plant* issue from a central axis Klee gave the picture a title with both zoological and botanical connotations. Polyvalence of forms is a feature specific to Klee's painting and one not encountered in that of his contemporaries. It results quite naturally from the procedure of constructing a picture from formal elements before these have acquired a representational function. The requirements of an individual picture, not those of an individual theme, caused Klee to delve into his treasure chest of forms and produce, say, coloured circles, which then give the picture its particular life and, possibly, a particular subject matter.

Klee sets the rider on a strange horse in the drawing *Ride* (fig. 16). An artificial human puppet sits astride a stiff creature of lines. The title in the middle provides a calligraphic contrast, while the horse at top right is tied up to an almost ornamental enclosure rounding off the scene below. Neither this arena nor the activity of riding determines the movements, but drawing itself. This is drawing which obeys the laws it has imposed upon itself during its creation — just as it had seven years before in *Joseph's Chastity Disturbs the Lower Regions* (fig. 7), although that was less geometric. Tangible rhythmic laws — for example, parallelism — govern *Ride*. Klee gives himself over to freely spontaneous invention but, as always, guides it in the direction of the reigning pictorial laws. Everything is made from the same formal material. Even the rider — with, incidentally, one eye in contrast to his horse's two — is wooden, as though constructed from narrow boards. In places the line indulges in caprices infringing the law of parallelism — note, for instance, the round, scarcely representational forms in the enclosure and the lively flourish on the left.

16 *Ride,* 1920

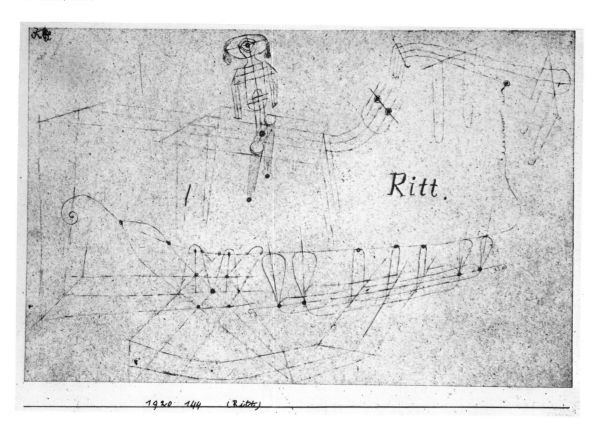

In another case Klee tells of an *Island Adventure* (fig. 17) of which he has happy memories. The drawing, containing hills and houses at the seaside and an indefinable structure below them, is littered with small signs and ciphers – among them the arrow which occurs so often in Klee's art and which was soon to play a part in his art theory. The magic of such drawings lies in their delight in graphic narrative invention, in the immediacy with which they reflect the creative idea, in their serenity of vision and rhythmic exactitude and, in the present case, in the poetry of conjuring up a dream-like island with both pleasant and unpleasant aspects.

Unpleasant matters occupy the foreground of the drawing. Something phallic emerges from a bubble-shaped structure on the right, which is hard to interpret. Klee's delight in sexual fantasies had not declined since his early etchings. Using the title as a guide, one might suppose the island to be recalled in the background and the adventure in the foreground. Klee does not provide a solution, but he stimulates the mind to find out what is represented. It hardly matters if one discovers things the artist was not thinking of.

17 *Remembrance of an Island Adventure*, 1920

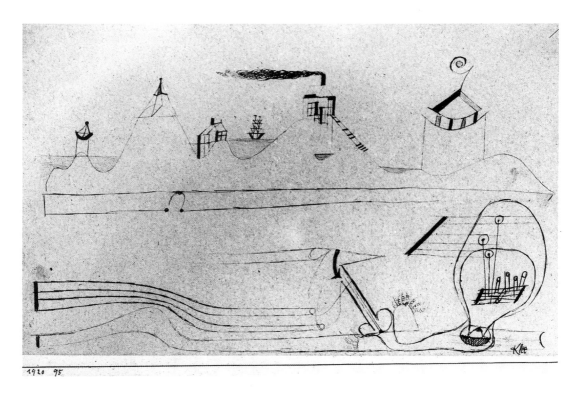

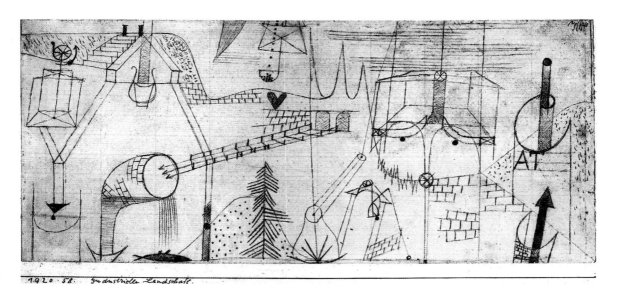

1920·58. Industrielle Landschaft.

18 *Industrial Landscape*, 1920

Klee depicts more mundane subjects in a similarly enchanting manner. In *Industrial Landscape* (fig. 18) a fish, heart, arrow and two inexplicable letters occur amidst a linear network formed by chimneys, pipes, rotating machines and factory walls. Memories are trapped in this web of lines. Klee by no means wished to address the problem of modern industrialism; rather, his concern was with a private piece of poetic draughtsmanship. He certainly did not intend to criticize, say, industry's brutal appropriation of nature – although nature 'survives' in the drawing only in the form of a thin little fir tree. Neither is he deploring human 'alienation', for people do not appear at all – or, at best, in the shape of the heart placed among all the mechanical activity. At this time a number of artists were indeed treating technology and machines with satirical irony, on the one hand, and enveloping them in a poetic aura, on the other. In particular, artists associated with Dada – like Marcel Duchamp, Picabia and Max Ernst – ridiculed belief in technical progress by depicting pseudo-functional, pseudo-technological gadgets. To these Klee added his famous *Twittering Machine* in 1922. *Industrial Landscape* also belongs to the realm of parody in its slanting of rational mechanisms towards the irrational. By means of witty draughtsmanship, the charm of free fantasy, the playing down of momentous happenings and, not least, by the humorous inclusion of a heart in inappropriate surroundings Klee humanized the 'inhumanity' of machines.

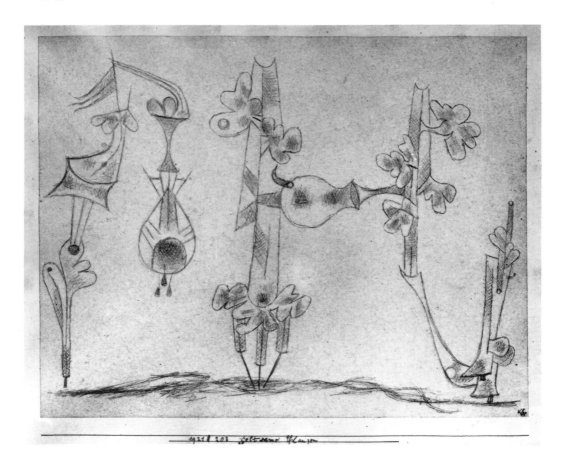

19 *Strange Plants*, 1921

There are any number of plants in Klee's work, yet they seldom exist in nature: he invents them too. Time and again his pen or pencil allows itself to be drawn into peculiar forms and strange natural moods which, of course, are the moods of the draughtsman's hand. Nature appears more surreal than real. Nevertheless, Klee is fascinated by one thing which does indeed form a part of the natural world: the growth, genesis, development and flowering of plant-like shapes. His fantastical plants always betray the forces that gave them life. For Klee, nature is not a final state but one of becoming. His concern is not with what he once called "final forms" but with what caused their growth – with nature as genesis. Thus, he understood form, too, as something in a state of becoming. In 1924 he wrote: "Formation determines form and therefore stands above it. Form may never and nowhere be considered as something accomplished, as a result or an end, but as genesis, as becoming." He also stated: "The artist is more interested in the forming energies than in the final forms.

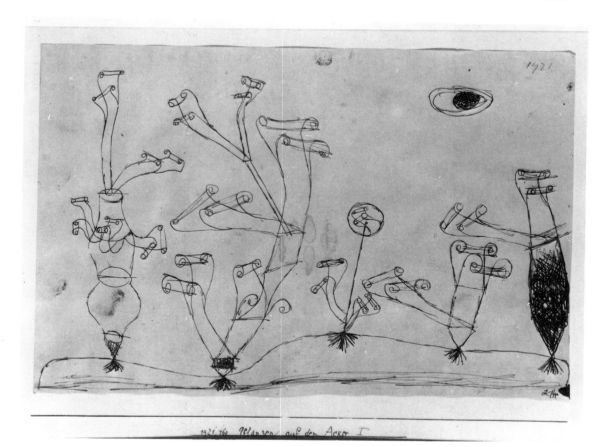

1921 16 *Pflanzen auf dem Acker I*

20 *Plants in the Field I,* 1921

The deeper he gazes, the more a finished image of nature gives way to the only image that counts – that of Creation as genesis."

In *Strange Plants* (fig. 19) and *Plants in the Field I* (fig. 20), both dating from 1921, he lets the plants shoot up from the earth and develop into curious shapes by means of the forces which suck them and their roots out of the soil. In doing so, he says more about growth and development than about any particular botanical species. In *Plants in the Field* the forms rolled up at the end are obviously lines and strips rather than leaves. By contrast, the growing herbs in the other drawing, though imaginary, are 'real'; the eye delights in following their ingenious formations step by step. Klee is not saying, 'nature looks like this', but 'nature lives like this and its vital energy might cause it to look like this'. He accepts nature's laws while expanding its stock of products.

Figures turn up again in *Maenadic Terror* (fig. 21). Four
bipeds with large heads – perhaps parents and their child-
ren – are suddenly driven apart by some invisible event.
Swift pen strokes form ovals and parallels, heads and
limbs. Instead of being terrifying, the drawing is full of
humour.

Head with German Beard (fig. 22) shows how Klee toned
down the parodistic element in his drawings when trans-
ferring it to the more serious realm of painting. In the first
place, the picture consists of richly orchestrated colours
applied to a formal fabric composed of intersecting lines
and the areas they produce. Yet it also possesses a clearly
articulated subject. Without the title, one would recognize
a disagreeable man with his moustache (or one half of it)
twirled up conceitedly and with an unpleasantly distorted
mouth. The title alludes to the German kaiser, whom Klee
ridiculed in other works, too. This explains the mixture of
inadequacy and pathos, mendacity and heroic posturing –

21 *Maenadic Terror,* 1920

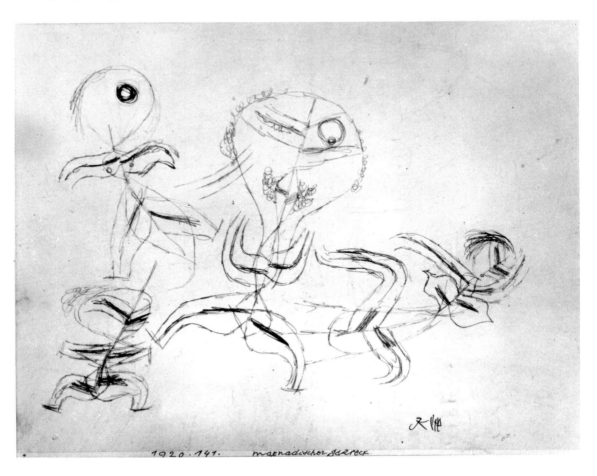

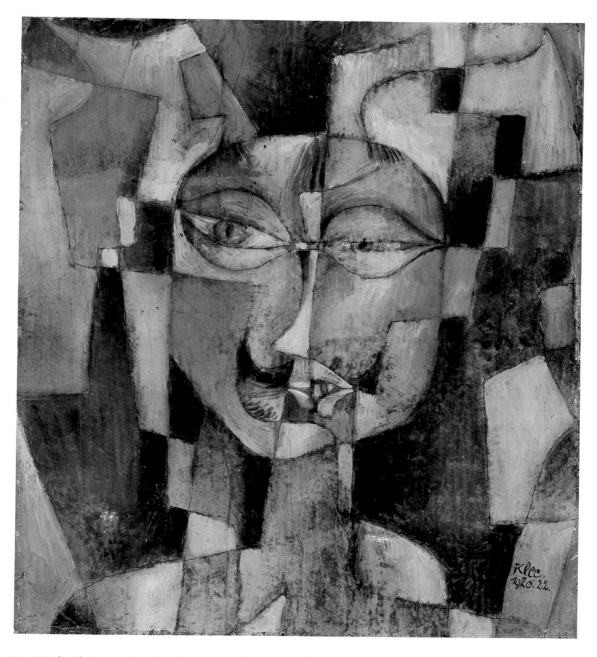

22 *Head with German Beard,* 1920

the latter also evoked by the 'Wagnerian' helmet. However, biting satire retreats behind the pictorial qualities constituting the image: Klee cannot be called a political artist on the evidence of this picture.

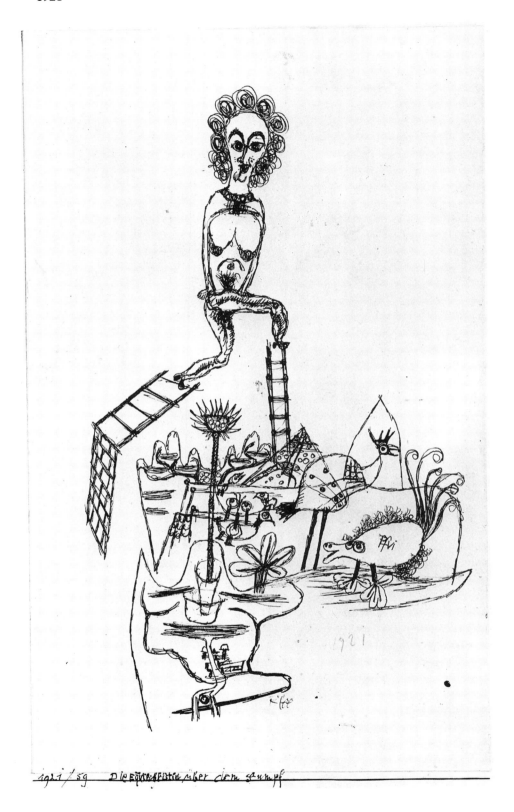

1921/59 Die Zwitschermaschine über dem Sumpf

23 *The Equilibrist*
above the Swamp, 1921

Klee's art took on a more rational character during his Bauhaus years. It became more geometric, for instance. Nevertheless, geometry had to remain foreign to someone who habitually sought the irrational rather than the rational: therefore, Klee always included elements that upset the geometry of his works. The spirit of geometry loses some of its absoluteness in his art. Klee expressed his reservations about geometry in sentences like this: "We construct and construct, and yet intuition is still a good thing." He rated intuition higher than geometry and construction.

Furthermore, Klee remained a story-teller, imagining, mocking and dreaming. The demands of rational art seldom thwarted him — least of all in his drawings, where he spins out his tales just as irrationally as ever. He simply starts drawing and lets himself be surprised by the results — for example, by *The Equilibrist above the Swamp* (fig. 23). Like a creature of the bog, a naked woman stands on a trapeze above the plants and animals of a swamp. The word "Pfui" ("ugh") appears in the stomach of the pig. Ugliness, loathsomeness and repulsiveness — that, too, is a part of Klee's poetic world and one presented just as poetically as the others.

A certain baseness is also apparent in the oil sketch *The Impudent Animal* (fig. 24). An elongated creature, with a long mouth and insolently raised tail, lurks beneath a face and 'naively' drawn trees. Klee's contemporaries often charged him with childishness. Indeed, he frequently availed himself of the stylistic means employed in children's drawings, just as he was impressed by drawings by

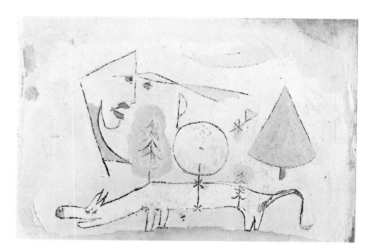

24 *The Impudent Animal,* 1920

the mentally ill when they were published in an influential book of the time. One repeatedly encounters such elements in Klee's art. At this time artists were fascinated by the 'primordial', so they naturally scrutinized the art of children and the mentally ill – not to mention that of 'primitive' peoples, which they began discovering shortly after 1900. They welcomed all pre-naturalistic, pre-civilisatory art, yet their preoccupation with the 'primitive' and 'naive' was anything but naive. Klee had this to say about the matter: "If my works sometimes give a primitive impression, then this 'primitiveness' is the result of my practice of reducing things to a few essentials. It is economy alone, thus the ultimate professional knowledge. In other words, the opposite of true primitiveness." *The Impudent Animal* is not only naive, but also strange and witty. Although not subject to any pictorial laws transforming reality, this picture, too, resists a comprehensive interpretation.

It is understandable that the Surrealists held Klee to be one of their own in the mid-1920s. But in spite of his penchant for the fantastic, absurd and recondite, Klee differed from them. He always believed in nature, even if he sometimes seemed to wound or offend it. However much he expanded, transformed or distorted it, nature and its laws remained sacrosanct to him. A "dialogue with nature", as required by Klee, was simply not a Surrealist demand. Klee's drawings continually produce the most peculiar monstrosities, but these are always seen as possible forms of life on earth and not as 'higher' – surreal – realities. Significantly, these creatures nearly always stand on the earth or, at least, on a strip of ground: they inhabit an earthly stage rather than a far-off dream world. This is so in *The Equilibrist above the Swamp* (fig. 23) and in the drawing of a girl whose nose grows into a glass containing a long-tailed bird (fig. 25). The title alone disclaims any surreal intent: an everyday phrase suffices to denote a drawing which, in the first place, is nothing other than a drawing. The vitality of the draughtsmanship itself summons up the figure of a girl who, though caricatured, is not transposed to a surreal plane. From his earliest etchings, Klee often treated the physical and personal unpleasantness of human beings, thus remaining in the realm of the Human, All-too Human.

Ecstatic Priestess (fig. 26) and *Glass Figures* (fig. 27) prove the point. Both are ingenious and witty. One cannot do them

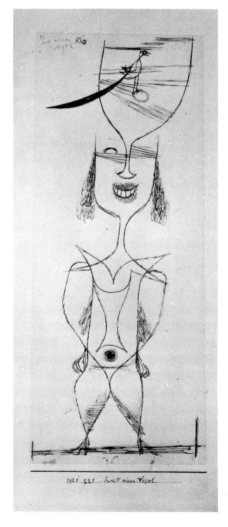

25 *Having Bats in the Belfry,* 1921

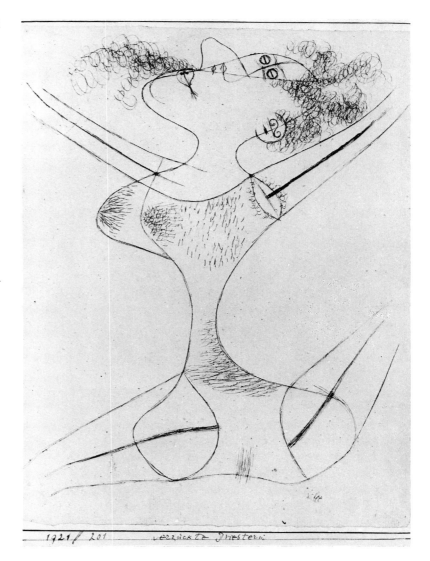

complete justice by looking at them solely in relation to their titles. Klee habitually added titles afterwards, drawing inspiration from the painting or drawing itself. "The titles," he once warned, "point in only one direction felt by me. Do not equate title and intention." It was certainly not his aim to depict an ecstatic priestess. His pen brought forth unexpected forms, which appeared to him to resemble a priestess in ecstasy. He then helped with an addition or two – such as the ecstatically whirling locks of hair. To become aware of this formal autonomy one need only observe how the oval divided in two by a straight line is repeated as an eye, a nostril, an arm-pit, etc. Wit informs not only the subject matter, but also the lines and strokes

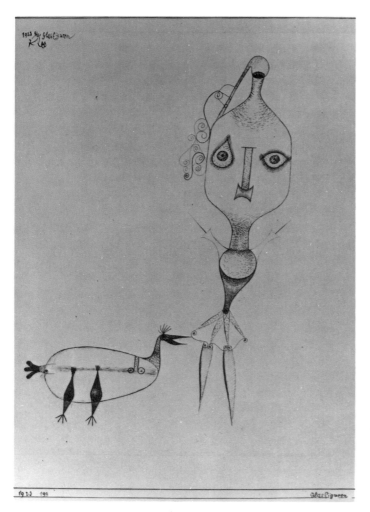

themselves. In *Glass Figures* one has to follow every flourish, tail and hair to understand how lines, dashes and dots produced glass structures which, if one wishes, may then be called glass figures. The humour here is certainly black, as it mocks the daintiness of a ballerina and exposes her as an ugly, malicious creature who is not to be trusted. This wit is not amiable.

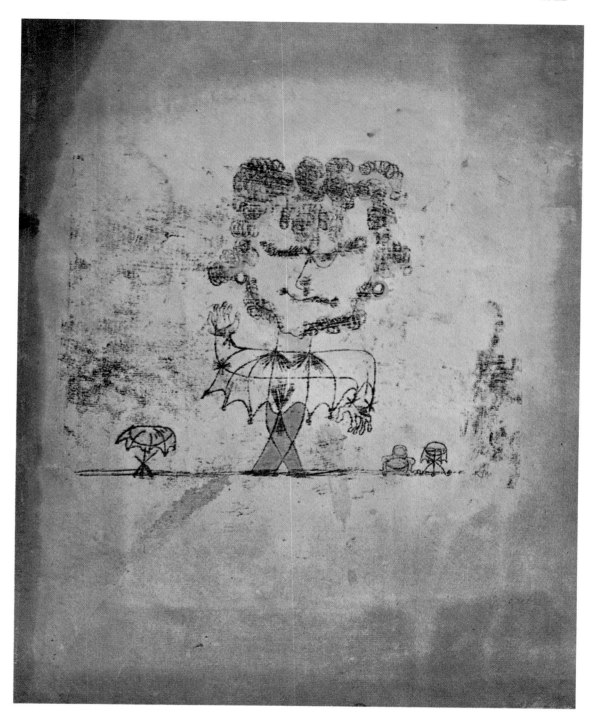

28 *Sganarelle*, 1922

All his life – and particularly in his Bauhaus years – Klee loved the theatre, opera and circus. For him, they represented a world in between reality and appearance, a world of enchantment, of the unreal and fantastic – and

hence, a world opposed to the rational. His work, especially in the early 1920s, bears witness to this love of the theatre as well as to an ironic love of the theatrical. In *Sganarelle* (fig. 28), for instance, he depicts Molière's character surrounded by diminutive stage props. Here too, mockery and irony are at work: with her outsized head and grotesque facial expression, the lady gestures in the exaggerated manner of a conjurer. Her face is thoroughly disagreeable, and gives the lie to the view of Klee as merely an amiable spirit. Many of his works, and his diaries too, prove how caustic he could be. Nevertheless, this picture causes amusement rather than anger or revulsion. And once again, the painter is concerned less with the absurdity of an actress than with artistic ideas. Even in this relatively anecdotal picture the ideas are subject to rhythmic formal laws: harmony exists between the occupants of the stage, however much their significance may differ.

In this picture Klee employed a special technique. Having created an indeterminate space with watercolour, he used monotype to populate it with the figure and props on a horizontal line. The drawing was executed on a zinc or glass plate and then imprinted on the sheet. By this means the artist presumably sought a better integration of his drawing with the surrounding watercolour. The sheet itself acquired a granular texture through the pressure applied during printing and this combines with the tonal gradations of the watercolour. Klee often used monotype at this time.

Lions, Attention Please! (fig. 29) also depicts a stage show. A female (?) animal trainer appears in a circus arena flanked by a female acrobat and a clown. At the trainer's command the lions shy off into the corner. The lions are hardly real (hence "attention please") but more like toys, just as the whole seems to be a toy circus or a puppet show. None of this is stated categorically — an impression of play and acrobatics suffices.

The painting had already been poetic before the actors made their entrance on the stage. Becoming progressively darker towards the edges, the squares filling the picture plane move through the finest tonal gradations to produce a pictorial space which is also a light space and a 'musical' space. Klee then indulges his passion for story-telling,

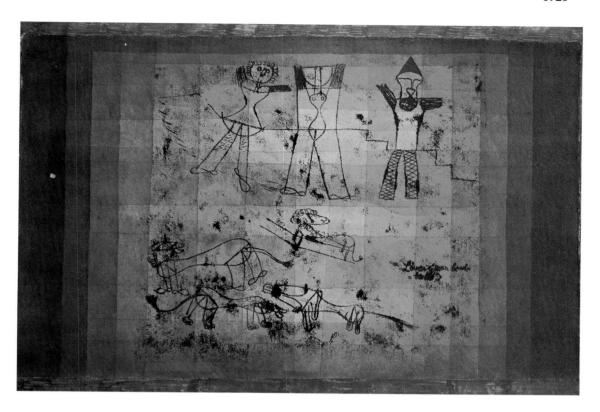

29 *Lions, Attention Please!*, 1923

adding drawing to painting, line to colour, melodic detail to polyphonic harmony and humour to pictorial seriousness.

Klee's life-long practice of dividing up pictures into squares underwent changes. Although still not strictly mathematical, the grid has become less freely painted and more linear, regular and geometrical than in the pictures of around 1920. One notes the influence of Bauhaus rationality. The relatively rigid system also recalls Robert Delaunay, whose inspiring theory of light and colour had affected Klee so strongly around 1910. However, the cosmic emphasis underlying Klee's colours in his Romantic phase of just a few years previously has now given way to a stricter method. He grades his colours as if carrying out an exercise from the Bauhaus curriculum, although his sovereign artistry prevents him from becoming in the least dogmatic. Upon closer inspection one notices deviations within the systematic passage from light to dark. And quite apart from the lively stage activity, black traces of the monotype process 'disturb' the structure and 'defile' the purity of the light.

Klee's occasional uses of geometry always include a demonstrative rejection of it – as in the watercolour *The L-Square Under Construction* (fig. 31) and *Sequel to a Drawing of 1919* (fig. 30), both dating from 1923. The works are related in their combination of large curving lines and small-scale geometric forms. In the houses and church of the more important of the two sheets Klee has, significantly, imputed a representational function to geometry. *The L-Square Under Construction* depicts both a town square and a plan of it. The artist has included the word "plan" in the picture, along with the letters, B, C and L – the latter in connection with "Platz" (town square). A circle functioning as the sun, an arrow signalling a directional movement and planks and ladders indicating the building being done complete the scene. As so often, the background consists of a grid of irregular rectangles.

The typographical elements are given considerable prominence. Although not exclusively formal, they do not, of course, possess any literal significance: they carry a meaning which remains obscure. Letters had been a favourite means of underlining the non-naturalistic character of painting ever since the Cubists had begun including typographical elements in their work around 1910. While in Cubist pictures their meaning is usually readily apparent – as, say, the title of a newspaper or the label of a cognac bottle – with Klee they acquire a 'semantic' nature: full of significance, they yet resist interpretation.

It is worth taking a closer look at *The L-Square Under Construction*. The squares are less systematic, more irregular

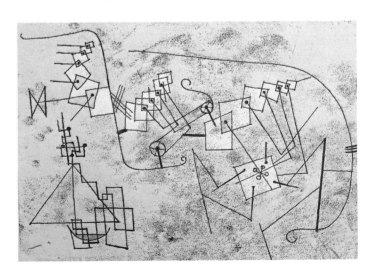

30 *Sequel to a Drawing of 1919*, 1923

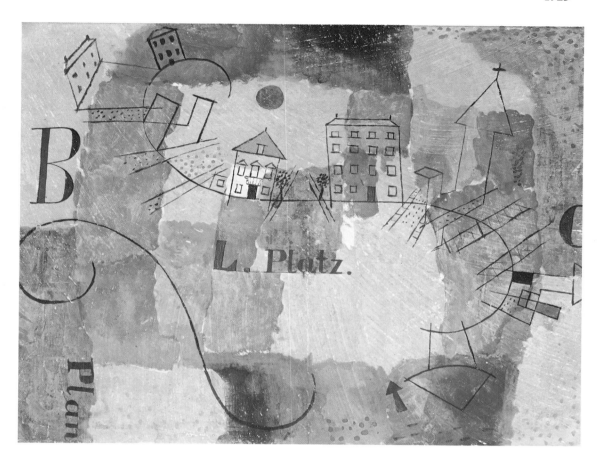

31 *The L-Square Under Construction*, 1923

than in *Lions, Attention Please!* (fig. 29) of only a year previously. This alone shows that Klee never allowed himself to be seduced into repeating a formal idea too often, however fruitful it may have been. The colour contrasts have become more marked and the colours themselves brighter than any in Klee's work up to this time. A unified scale of tonal values no longer exists, permitting the colours to glow with greater brilliance than in, say, *Cosmic Composition* (fig. 13), where they glimmer mysteriously in the dark. On this coloured ground – which seems almost to deny its cohesive function – Klee sets down the details of L-Square. He lines up the houses on a curving line, in the same way as he had placed the actress and props on a horizontal strip in *Sganarelle* (fig. 28). The ornamental effect of the line is increased by the addition of a similar one echoing it symmetrically; together, they also mark the edges of the town square. Just as children do, Klee tilts the houses at an angle when the base line curves. One hardly notices that the square is seen from above, the houses,

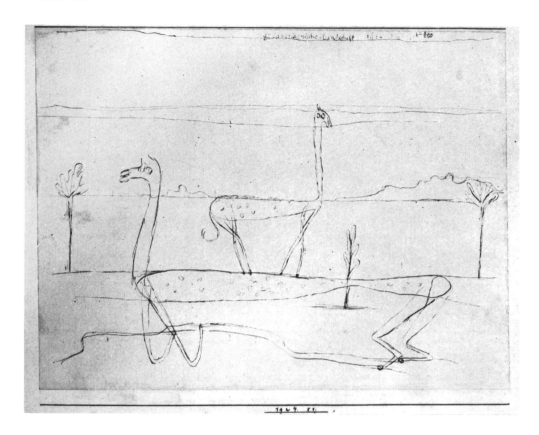

however, from the front. Here and there – for example, at the right-hand edge – Klee plays little formal games which, having no relevance to the subject matter, appear like marginal exercises in Bauhaus geometry. In his work and play with forms and objects Klee is unwilling to sacrifice the spontaneity of free fantasy to the strict formalism of the Bauhaus.

32 *South American Landscape (with two Llamas)*, 1924

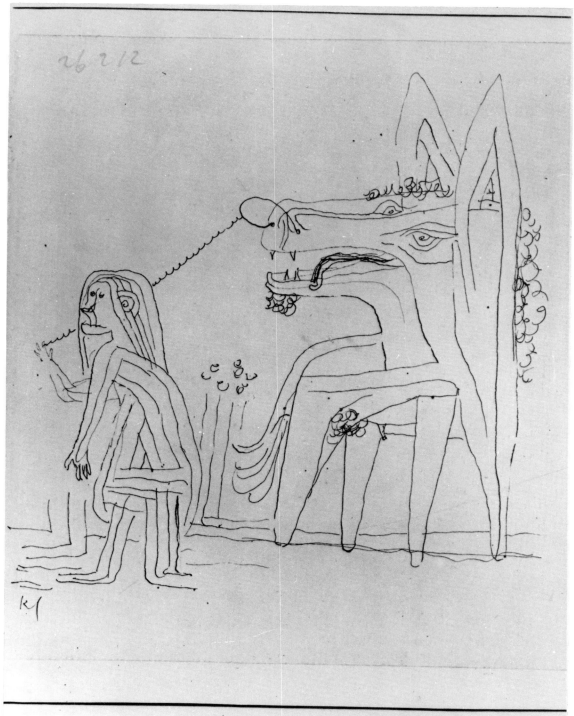

1926. N.4. Hengstzähmung

33 *Stallion Taming,* 1926

And he continues drawing. In 1924 and 1926, for instance, Klee produced a *South American Landscape* (fig. 32) with two distorted llamas; *Rotation* (fig. 34), consisting of abstract radiating forms reminiscent of organic objects such as plants or capillaries; *Overculture of Dynamoradiolars* (fig. 35), depicting two plants with rotating flowers under a title which vies with botanical terminology and mocks science; and, finally, *Stallion Taming* (fig. 33), in which parallel lines once again give rise to creaturely forms.

This small group of drawings from two separate years reveals how free Klee felt in his choice of both subject and style. Two such contrasting pairs of drawings as *South American Landscape* and *Rotation*, on the one hand, and *Stallion Taming* and *Overculture of Dynamoradiolars*, on the other, originated in 1924 and 1926 respectively. Animals occur in two of these works, yet they are viewed quite differently in each case. In *South American Landscape* the llamas are pencilled in lightly, Klee's concern being to accentuate the contrast between standing and lying down. *Stallion Taming*, however, depicts a demoniacally threatening animal, intent on moving in the opposite direction to that in which a weary man is pulling it. The picture would seem to represent primitive man's first domestica-

34 *Rotation*, 1924

1924 30 Rotation

35 *Overculture of Dynamoradiolars 1*, 1926

tion of a horse but there is no reason whatsoever to suppose that Klee had this in mind. An intepretation of the subject matter must be content with registering a tamed stallion and an exhausted tamer.

Both the other drawings present the motif of rotation. In *Rotation* it is basically abstract (although one recognizes a bird losing its way among the flower-like jungle of lines) while in *Overculture of Dynamoradiolars* it is depicted in two plants, one simple, the other complex. The effect of accelerating rotation in the former work results from 'hairy' blades issuing off-centre from the circle in the middle, whereas centrifugal forms denoting rotation are responsible for the impression of rapid spinning in the plant drawing. A comparison with the drawings of plants made in 1921 (figs. 19, 20) shows how Klee has departed further from nature while remaining true to it.

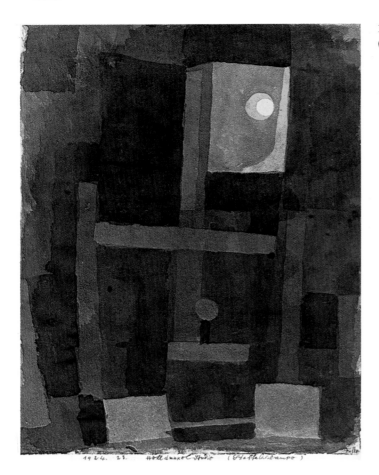

The watercolour *Study of Light and Dark* (fig. 36) demonstrates how little geometry must needs exclude the organic. Once again, Klee tempers the strictness of geometry: the shapes are only approximate rectangles (their corners not being exact right-angles) and the primacy of the picture plane, sacrosanct to the artists of 'pure' geometry, is ignored completely. The paint flows across the forms, thus reducing their severity still further. Everything exudes movement and life. Moreover, geometry is not put at the service of perspective. A sense of space emerges through the transparency of the light and through the light and dark grey tones, receiving only slight clarification by means of the easel and lamp in the foreground and the moon seen through a window. The theme of the picuture extends beyond the peace of an interior at night to embrace a profound spiritual peace. A work such as this explains Klee's admiration of German Romantics like Novalis and C. D. Friedrich even after Romanticism had ceased to govern his pictorial thinking.

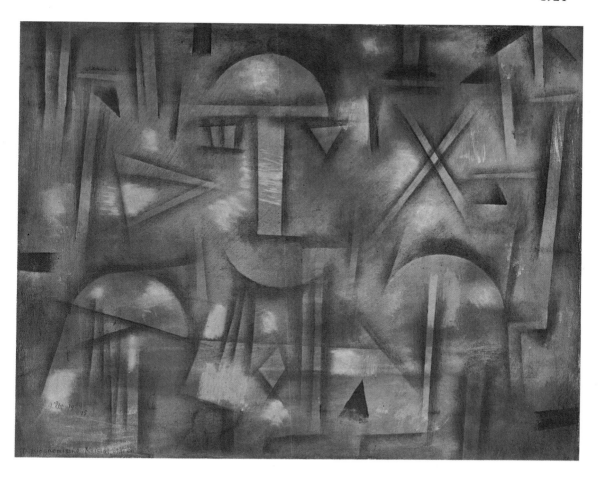

37 *Physiognomic Crystallization*, 1924

In the same year, 1924, Klee painted *Physiognomic Crystallization* (fig. 37), another many-sided picture of luminous transparency. One associates crystals with regularity and sharp-edged stereometric construction and, at the same time, with the mystery and wonder of nature. The title indicates that the picture's theme is not crystals themselves but crystallization – i. e. crystals in a state of growing and becoming, in the process of attaining their final shape. Shadowy memories of faces emerge from the mobile play of bars, crosses, triangles, rhomboids and segments of circles. The crystalline becomes human, the human crystalline – a reflection, an illusion, a Fata Morgana. Distinctions evaporate in this state of continual metamorphosis, as the amorphous becomes organized, the organic inorganic, the rational irrational, the purely formal real, and the real dreamlike and miraculous. All this is the work of crystallization; all this is the work of Klee's pictorial thinking. This thinking dissolves the boundaries between sepa-

rate realms: *everything* is relative when viewed in terms of the absolute, in terms of the 'Universal One' of German Romanticism. "The visible," Klee says, "is always merely an isolated example in relation to the totality of the world." This totality is invisible; but it becomes visible through art, for "art does not reproduce the visible, it makes visible".

Time and again the works of Klee's Bauhaus years show that his occupation with geometry never cramped his imagination, his delight in narrative or his humour. Indeed, these avail themselves of geometrical forms, in complete opposition to the tenets of the orthodox geometric artists among the avant-garde of the time. With Klee, geometry – which he by no means avoids – ceases to be dogmatic. In *Monsieur Pearlswine* (fig. 38) the eyes consist of squares and the collar of triangles. Here, the technique of covering sections of the picture and then spraying watercolour over them – one often employed by Klee at this time – comes to the aid of geometry. However, spraying gives rise to overlappings and transparency and these, in turn, neutralize geometry's hard-edged sharpness. Klee plays with geometry. Through it he pays tribute to the Bauhaus spirit without, however, utilizing it as a matter of principle. In modifying geometry's claim to absoluteness he distanced himself from what was becoming something of a dogma both at the Bauhaus and in the art of the 1920s as a whole. For Klee, geometry was just one of a limitless number of artistic means. His temperament, thinking and artistic spontaneity prevented him becoming a 'pure' geometric artist or a constructivist.

One basically conventional motif runs through Klee's entire work: the frontal presentation of faces and figures as though they were particular people. In the case of *Monsieur Pearlswine* Klee gave his opposite number a name. The composition of this fictional portrait, so to speak, is thoroughly traditional. Not so the style and technique. The spray technique causes the sitter to appear as if constructed from pieces of paper, cut out and bent in places, and wearing a paper hat. The head comprises very few elements. One of them is the pearl on the collar which, together with the pink in the face and a certain air of unpleasantness, gave the gentleman his name.

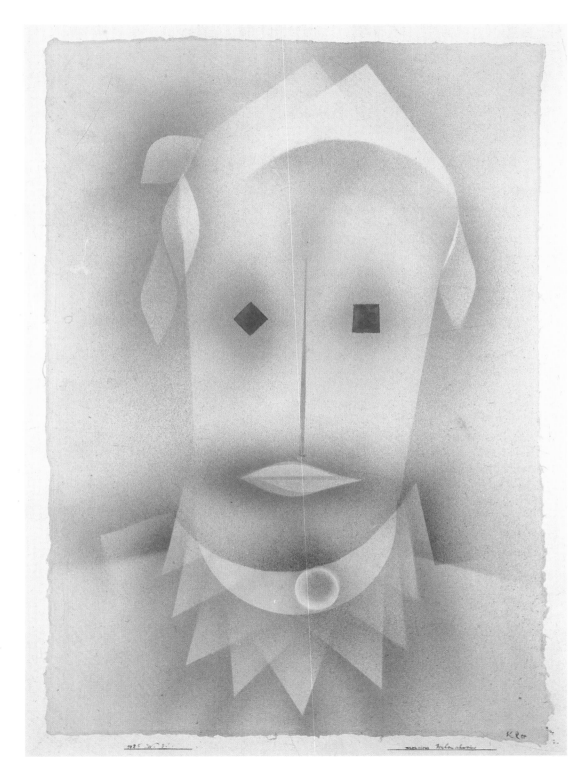

38 *Monsieur Pearlswine,* 1925

Klee considered reality to consist not only of the present but, most emphatically, of the past as well – that 'invisible' past which lives on in the present. His mind was always fascinated by dead cultures. In his painting he loved to discover traces of the past and to unearth relics of history – a kind of archaeological excavation by means of the brush. Delving into deeper layers of history meant fathoming deeper layers of the human soul, in order to disclose the archaism of the human soul in archaeological garb or, conversely, to present archaeological remains as symbols of buried layers of the human soul. He was thus profoundly affected by his visit to Egypt in the winter of 1928/29. In *Reconstruction* (1926; fig. 39) two Doric columns appear beneath the yellow Mediterranean sun with all kinds of archaeological remains below, and a modern house above, them. There exists, therefore, a progression from above to below, from the present to the past and from the external to the internal. With Klee, layers may be spatial or temporal, but they always correspond to layers of consciousness. He himself expressed it thus: "All art is a memory of the ancient and the dark, fragments of which live on in the artist."

He unearths such fragments in the yellow desert sand of *Reconstruction*: masonry, steps, markings on ancient stones and, at ground level, the last standing columns of a temple. As so often in Klee's pictures, a large incandescent sun stands, immutable, over the scene. In the pictures around 1920 the sun was a planet of the cosmos. Now it has become a 'pure' circle, a basic geometric form and, at the same time, the source of the scorching heat filling the sky, the desert and the picture as a whole.

All his life Klee was attracted to, and enthralled by, the Mediterranean world. It represented the opposite pole to his northern models, Caspar David Friedrich, Carus and Novalis: the ordered and archaic as against the romantic, fantastic and natural. He travelled in Italy. In 1914 he had visited Tunisia, where he came face to face with the Orient rather than with Antiquity. His journey to Egypt two years after painting *Reconstruction* provided another profound experience of history and the Orient. The picture itself, although it still contains Greek elements, shows Klee to be ready for an encounter with a more archaic reality.

Klee continued his game with geometry, at a time when many artists considered it a deadly serious business. Ap-

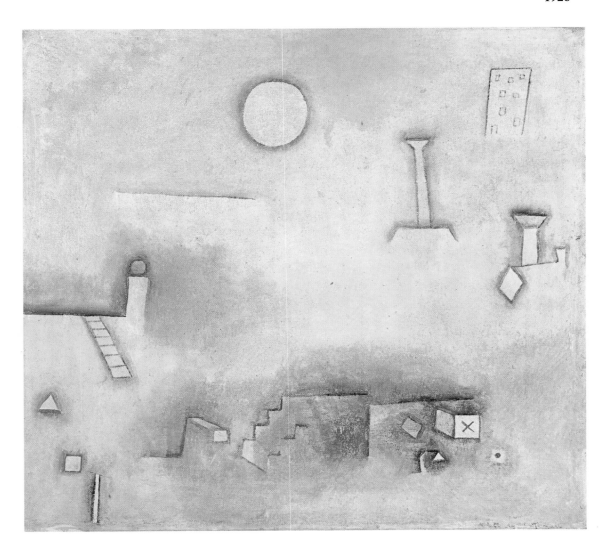

39 *Reconstruction,* 1926

parently contradicting his devotion to the organic, Klee delights in building architecture in his paintings and drawings – as in the magisterial drawing *Rio on Elba* (1926; fig. 40) or in *Little Week-end House* (1928; fig. 41). With architecture one usually associates the static, stable and constructional. Klee's architecture is alive, not static; unstable, not stable; and intuitive, not constructional. What holds good for construction and geometry in his work also applies to perspective: it is but one possibility among many – and a rarely used one at that. With Klee, perspective is both rational and irrational, both space-creating and space-confusing, and both static and dynamic. He abolished perspective as a general law of optics; yet, having once found it a "real bore" and having

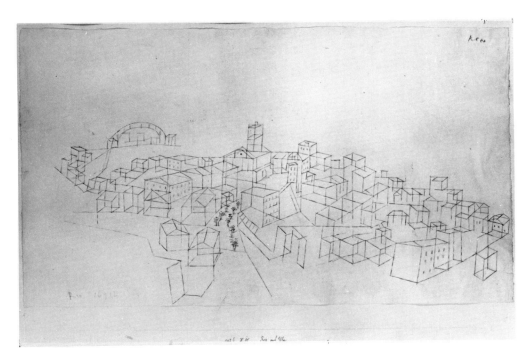

40 *Rio on Elba*, 1926

"overcome" it in favour of the plane in 1914, he now invests it with different, highly attractive qualities. Needless to say, he does not approach it from the scientifically correct point of view of central perspective (single vanishing points are nowhere in evidence) but neither does he reject it. In *Rio on Elba*, for example, he employs its means – which, after all, are remote from nature – to give the impression that a law of perspective does indeed govern the scene. In Klee's hands even perspective becomes an aesthetic sport.

Rio on Elba contains numerous hints of perspective but no unified vanishing point. A collection of transparent glass cubes conjures up a view of a seaside town seen from high up, with houses, medieval towers, a tree-lined alley and, on the outskirts, a large iron bridge. In a characteristic mixture of two spheres, Klee locates the town psychologically as well as geographically. By transferring far-off Rio to his beloved Mediterranean he brings dreams nearer home and removes Elba to a distant dreamland – for few people would associate 'Rio' with a place on Elba, which, in fact, it is.

Little Week-end House is a comparable work. Here too, architecture appears as a fragile construction, as a graphic game with cubes and rectangles, which obeys its own

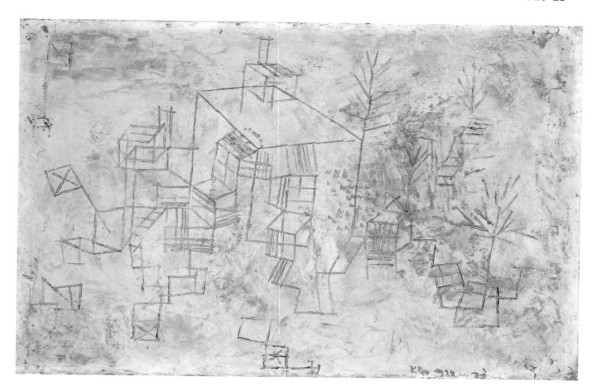

41 *Little Week-end House,* 1928

rules, not those of a foreign architecture. Again, perspective is hinted at, but clear vanishing points and lines do not exist. The house consists of a lively up-and-down of green lines which, like the components of a house of cards, are playing at houses, as they indicate the basic cube form, a bay window, a flag, etc. Their 'shorthand' also gives birth to trees. A few colours dabbed on loosely denote earth and sky.

Klee's art is not simply a succession of multifarious transformations and changes; certain things in it remain constant over the decades. In spite of dissimilarities, it is remarkable how close *Little Week-end House* is to *Cosmic Composition* of 1919 (fig. 13), which originated in a totally different artistic and mental climate. There too, Klee had constructed a house from a few slender lines, depicted fragile ascending steps and drawn trees almost identical to those in the later picture. Even the same subsidiary forms – such as crosses inscribed in squares – occur in both works.

The picture *43* (fig. 42), created in the same year as *Little Week-end House,* shows how Klee employed the constructivist and rational ideas of the Bauhaus while remaining true to himself. He pays tribute to construction by designing a linear structure of rectangles, triangles and rhombuses. Nevertheless, the spirit of the painting is plainly ungeometrical. A number of features work against the principles of geometry: the irregular edges of the picture; the green which automatically suggests nature and induces one to see the red circle not as a geometrical figure but as the sun or some other heavenly body; and the manner in which Klee anchors the lines to the background with light brown. He adds softness to hardness as though compelled to relieve the immovable lines of their rigidity. He mistrusts strict laws everywhere, trusting in nature instead. As in many of his pictures, the irregular edges express his dislike of forms that are too final.

The number 43, like the letters in other pictures, dominates the painting, giving it both its title and an additional evocative element which, although without definite meaning, is certainly not meaningless. Through its prominence the number acquires a significance, the sense of which remains obscure. Leaving questions open is a legitimate artistic means, provided that the form in which the questions arise is appropriate to the picture. To ask the meaning of the number 43 is thus superfluous. Rational thought may object that such artistic practice remains non-commital and imprecise, since the beholder must decide for himself whether the number – and why 43 exactly? – is valid or not. Yet the same applies to any form in any picture. Klee includes the number both as a 'pure' form and as something important to the content – just as a house number acquires importance and meaning for someone living in that particular house. In this picture the number is indeed like that of a house.

Thus, even this painting, which totally excludes objective representation, may hardly be called 'abstract'. One senses nature, almost a landscape with a hint of an horizon. The coloured ground is rich in movement and the overall mood of the picture is that of nature. The eye of the beholder is drawn into an extensive pictorial space, its passage gently assisted by such suggestions of linear perspective as the rhomboid on the left.

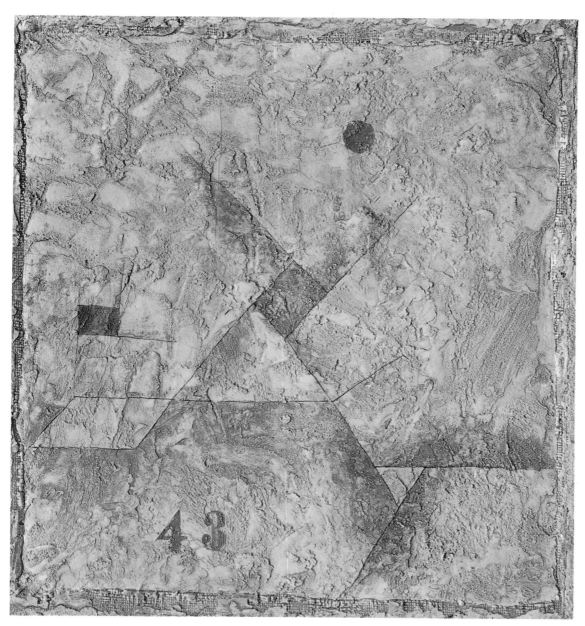

42 43, 1928

43 *Black Prince*, 1927

In *Black Prince* of 1927 (fig. 43) two circles for the eyes, an angled bar for the nose and two straight ones for the lips are the 'naive' means employed for a 'primitive' subject – a picture-book Moorish chieftain (oddly enough, with blue eyes). The star, crown and richly patterned clothing bear script-like markings as signs of the exotic. All this glows strangely in the dark. In portraying this black fairy-tale prince Klee also portrays the black continent, a remote world of the mysterious and fantastic. He does so

44 *The Burdened One,* 1929

with the simplest of means and not without a touch of irony. However, the picture can also be interpreted seriously. As usual, Klee leaves matters open.

Parallel to such anecdotal detours Klee continues his series of geometrical pictures with scarcely any narrative features. In *The Burdened One* (fig. 44) we confront a structure of intersecting straight lines, its vaguely human form emphasized by the addition of two strokes for the feet and two dots for the eyes. Viewed figuratively, the form can be seen to represent a figure loaded down with packages — hence the title. But one may also recognize it as a puppet hanging on a string. All interpretations are valid if suggested by the artist; if he leaves things open, then vagueness was part of his intention.

The intersecting lines could hardly have foreseen their representational goal: the shape might easily have become a house, yet it revealed itself to be a human figure instead, with two dots for eyes clinching the matter. A sense of space – assisted by the loose painting of the brown background – also arose during the genesis of the figure, but its effect is limited by two blue horizontal bars which emphasize the picture plane and form a kind of horizon, with the heavily laden figure projecting above it.

A smaller picture, which Klee called *Fireworks* (fig. 45), consists of a loose arrangement of vertical and horizontal lines, a few rotating shapes and a star. Once again, these are geometrical forms, but set in motion and intelligible as fireworks against a dark background.

A similar procedure occurs in another picture, in which sharply angled lines flash out from a dark blue background to form *Many coloured Lightning* (fig. 46). The nocturnal atmosphere is underlined by the orange moon, the sense of mystery by the solemn sign at bottom left. This sign may be interpreted as something holy (a church perhaps) or as a house standing under a particular star – a motif occasionally encountered in Klee's work. As so often with this artist, a moon shines in the lightning-racked sky.

45 *Fireworks*, 1930

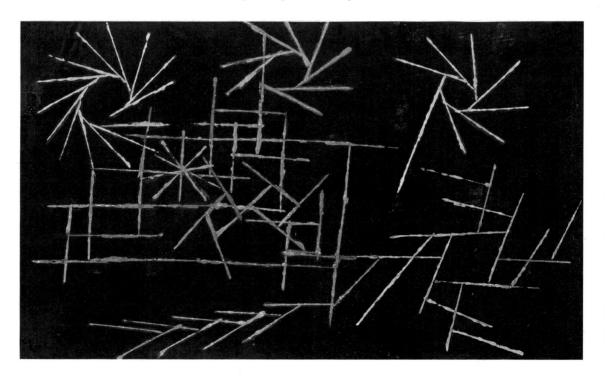

46 *Many coloured Lightning*, 1927

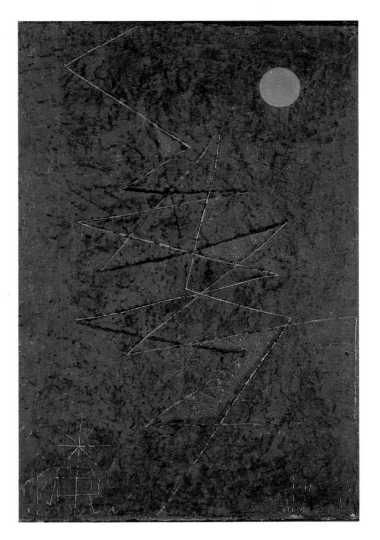

Pictures like this suggest that Klee was not only employing geometry in his own free way, but also exemplifying some of the theories he developed at the Bauhaus and passed on to his students there. His *Pedagogical Sketchbook* explains, for example, how the character of a line may be altered by formal means – how, say, a line can be made to rotate or to flash like lightning. Surviving transcriptions of his Bauhaus lectures contain exercises which apply directly to the three pictures from 1927-1930 discussed here.

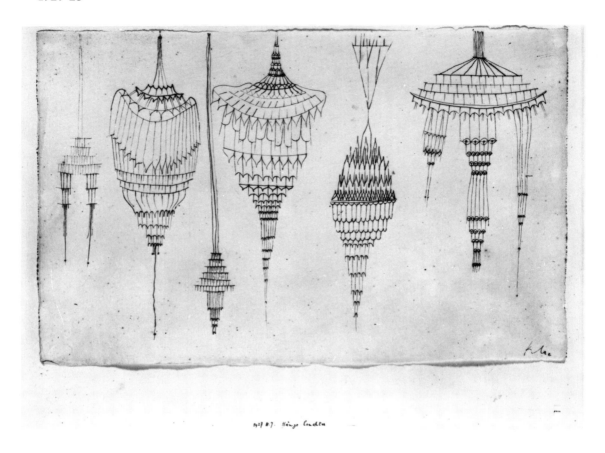

47 Hanging Lamps, 1927

Alongside these stricter formal exercises, and far removed from geometry and theoretical speculation, Klee continued to play with line. *Hanging Lamps* (fig. 47) is the title of a drawing in which the rhythm of the forms produces elaborate chandeliers. One notices Klee's enjoyment in letting himself be guided by these graceful linear rhythms. The forms and their combinations arise almost automatically until, at some point, the artist thinks of chandeliers and his hand follows this idea. With Klee, there exists a strange interaction between form and content, one which changes from painting to painting and from drawing to drawing: sometimes it is form, sometimes content which takes the initiative.

Similarly, the drawing *In the Air above the Water* (fig. 48) started out from a particular graphic rhythm, quite different from that in *Hanging Lamps* yet still completely autonomous. Not until later did it acquire representational character as a balloon with a flag, a boat and a kite from which a man or puppet dangles as though from a para-

48 *In the Air above the Water*, 1928

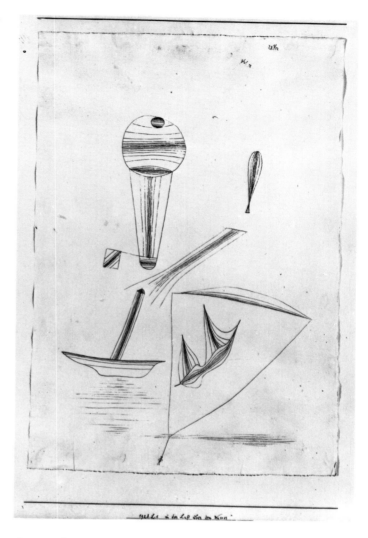

chute. Klee was especially fond of water and air, two elements which, not belonging entirely to the earth, cause forms to hover, swim, sink and fly. A comparison between *In the Air above the Water* and *Hanging Lamps* not only reveals a completely different graphic character, it also provides further confirmation of how Klee varies the relative shares of form and content from work to work. In *Hanging Lamps* objects are represented by association, as the result of a formal game with lines. In the other drawing the artist is more concerned with story-telling, narrating an event at sea as the mood takes him. Yet even here he sacrifices none of the autonomy of his linear language.

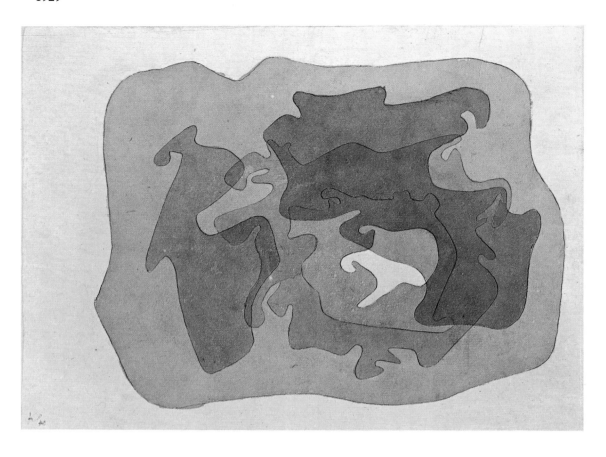

49 *Atmospheric Group in Motion*, 1929

Klee once wrote: "The whole action can be transferred to an intermediate state such as water or atmosphere, where no predominant verticals exist (as in floating or hovering)." He also declared: "It is obvious that different functions produce large variations in different elemental realms." Klee depicts natural objects under the varying conditions of the "elemental realms" earth, air and water, explaining this in detail in *The Thinking Eye*. The watercolour *Atmospheric Group in Motion* (fig. 49) shows forms subject to atmospheric energies: in a state of becoming, of continual metamorphosis, they revolve irregularly around an atmospheric centre in obedience to a secret law of nature. Translucent watercolour is a particularly happy medium for suggesting the transparency of air, light and space. A passage in *The Thinking Eye* reads like a description of pictures like this one: "This form of expression tries convulsively to fly from the earth and eventually rises above it to reality. Its own power forces it up, triumphing over gravity. If, finally, I may be allowed to pursue these forces, so hostile to earth, until they embrace the life force

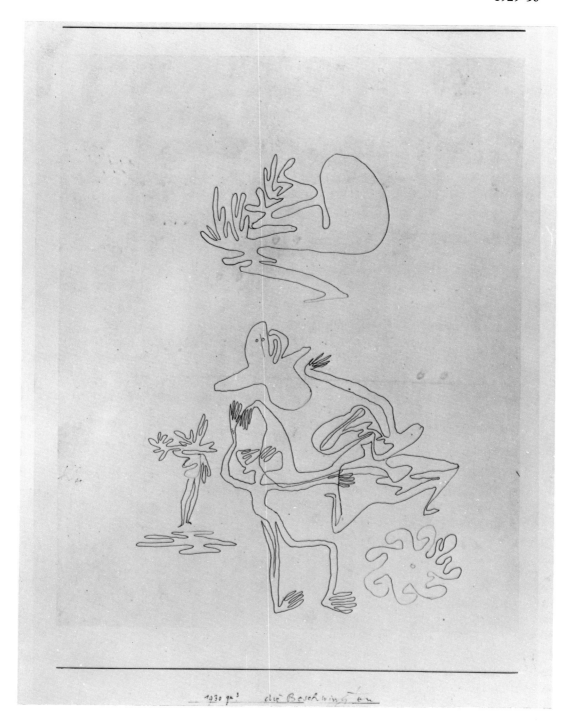

50 *The Elated,* 1930

itself, I will emerge from the oppressively pathetic style to that Romanticism which is one with the universe."

Such forces are at work in *The Elated* (fig. 50). The human figure which they engender at the bottom may be there just for a second, before vanishing again. Beside and above the figure, the airy space sporns rotating, flowing and hovering shapes. They owe their form to the atmospheric condition prevailing at that moment and may change shape again at any minute. This is nature as continual metamorphosis. Klee makes use of both spontaneous invention and established means. The rotating motif at the lower right, for instance, immediately recalls the way in which he had set forms spinning a few years earlier in *Overculture of Dynamoradiolars* (fig. 35). Having studied the motif, he imparts it to his Bauhaus students while continuing to employ it himself.

With its four limbs clearly marked, the figure at the bottom of *The Elated* is a relatively complete human form. More diffuse ones also exist in the drawing. The shape standing to the left of the central figure is a vaguely human biped consisting of a single line left to its own devices as it travels upwards. On the right, another figure seems to be running away from the central one while above it a strange being with two round eyes drifts away upwards. The lines travel freely between form and reality, giving rise to fantastic and witty shapes. Such forms must have delighted the Surrealists, who had already invited Klee to participate in their first 'official' exhibition in 1925.

One senses that Klee felt more at home in this world of organic form than in that of geometry and one notices, too, how the fluid medium of watercolour, with its ability to render forms more vague and transparent, was particularly congenial to him. *Exotic Sound* (1930; fig. 51) also represents a high degree of perfection. Careful examination of the interlacing configuration reveals it to consist of no more than two lines. The first describes a bottle-like shape. The second delineates 'abstract' forms: having started somewhere, it travels around the sheet, often crossing over itself, and finally returns to its point of departure. Areas of translucent colour arise between the lines and overlap in places. The bottle, integrated in the play of lines, is no more 'real' than the abstract forms; and the abstract forms are no more 'unreal' than the bottle. The picture is not a still life; it is hardly more than a simple, dreamlike ("exotic") sound.

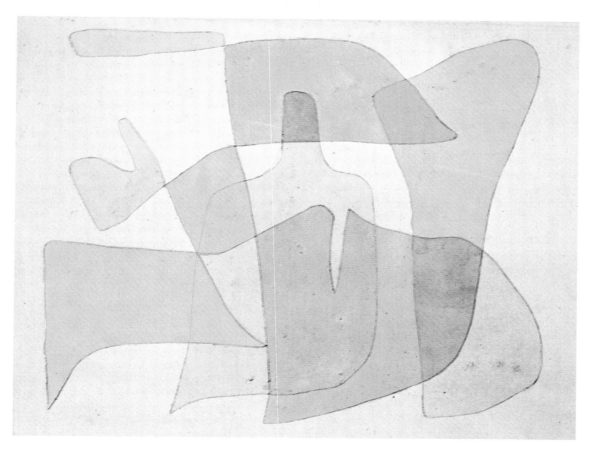

51 *Exotic Sound*, 1930

Intersection determines the character of the picture: the lines intersect, the coloured areas intersect and so do form and nature, in the manner peculiar to Klee. His penchant for intermediate zones shows him to think in relative categories, as opposed to the absolute ones of geometry and constructivism. There was room for both at the Bauhaus, where no one orthodoxy prevailed, its teaching staff encompassing a wide range of artistic standpoints. To be sure, these all tended towards rationality, but not to the exclusion of irrational attitudes. Indeed, the ideas which hat led to the founding of the Bauhaus in 1919 betray a degree of Romantic emotion far removed from the objective and technological ideology often associated with its members.

Klee travelled to Egypt in the winter of 1928/29, fourteen years after his visit to Tunisia. For him, this was a journey not only to a mysteriously remote country, but also to a mysteriously remote age. Whenever this 'archaic' element enters his art it describes simultaneously an element of the human soul: Klee conceived layers of history as layers of human consciousness, as 'archetypal' symbols of what C. G. Jung called the "collective unconscious". *Necropolis* (1930; fig. 52) must be viewed in this light. The earth's interior contains the remains of a burial ground, with arches and crosses symbolizing the past, death and the soul. When confronted with the past Klee experiences the reality of the unconscious: "The deeper he [the artist] looks, the more readily he can extend his view from the present to the past." That he did not need to travel to Egypt in order to realize this is demonstrated by a picture like *Reconstruction* (fig. 39), created in 1926, before his trip to Egypt.

Necropolis anticipates the severe, terse pictorial language of Klee's late years. There is nothing playful, ingenious or humorous about this sombre picture. Klee's repertoire of forms is generally simple, but here he cultivates a simplicity of style. Bold forms correspond to the stone monuments which the artist places above one another in serried rows. Here, too, spontaneity is in evidence, inasmuch as the forms and brushstrokes still reveal the painting process which determined their character. Yet at the same time, the forms are 'objective', used by Klee like the letters of an ancient alphabet. If cipher-like signs had possessed great significance in his early work, then the paintings themselves now occasionally become cipher-like. With the signs set down line by line, formal severity governs the picture to a far greater degree than in *Reconstruction* of 1926, despite the similarity of subject. That picture had been narrative in character: Klee told of various things that occur in and beneath the desert sand. By contrast, the necropolis of 1930 presents layer upon layer of graves with their tablets and signs, the round arches recalling the walled-up doors found in the burial grounds of Upper Egypt.

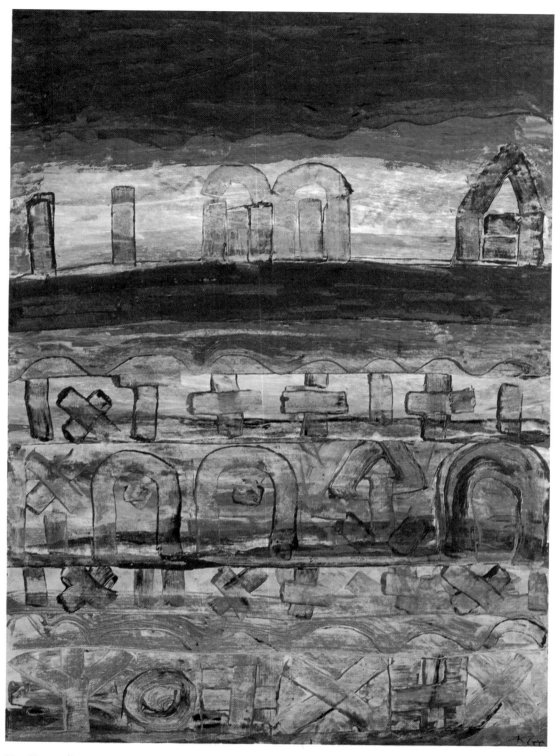

52 *Necropolis*, 1930

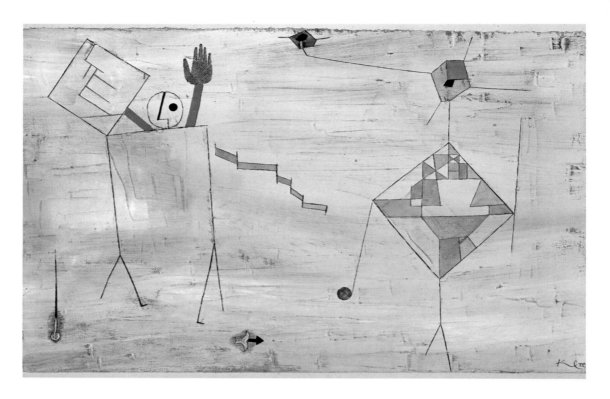

53 *Staging*, 1930

Klee remained haunted by the stage and the theatrical. *Staging* (fig. 53) was his title for a nimble picture bearing the marking *S. Cl.* ('Sonderclasse' = special class). A more or less abstract play is being enacted on an imaginary stage – perhaps that of a puppet show. A playful figure, with a cube-shaped body and sprouting antennae, stands on the right, while on the left the lid of a four-legged structure has just opened to allow a puppet-like actor to peep out in accordance with the producer's wishes. Less a painting than a drawing on a painted ground, the picture may well constitute a friendly parody of Kandinsky, since the two squares standing on their corners look like paintings by Klee's great Bauhaus colleague.

Has Head, Hand, Foot and Heart (1930; fig. 54), a water-colour painted on cotton, is a similarly light-hearted picture, although more of a finished image than *Staging*. First one notices four straight bars – a horizontal and a vertical one, and two moving in different diagonal directions – fixed in position by the red ground. Human features are grafted onto the bars: a face with two large circular eyes onto the horizontal bar; a foot onto the bottom and a hand onto the top of the vertical one; a foot onto the lower diagonal; and a hand onto the upper one. A red

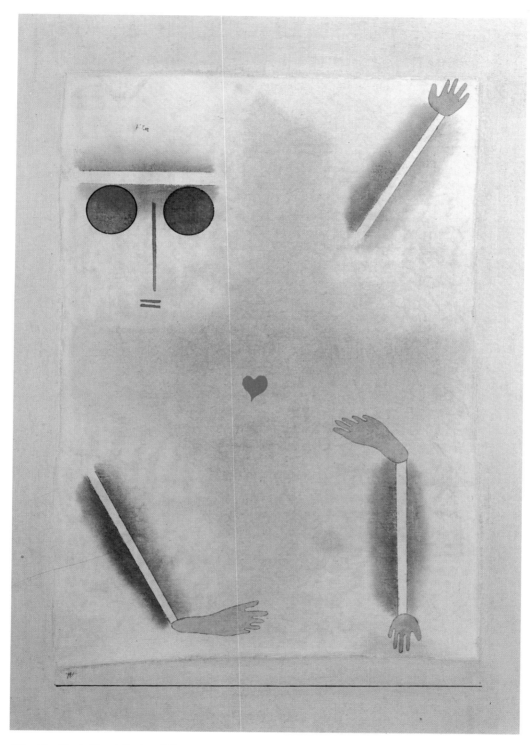

54 *Has Head, Hand, Foot and Heart*, 1930

heart is added in the centre. Focusing on the face, one imagines the figure gesticulating with its arms, like a juggler. But as so often, Klee admits no final interpretation. His chief concern was to produce a pictorial image containing an element of humour, with even the human heart not treated all that seriously.

Closer examination of the formal means employed by Klee in this picture reveals a feature already encountered in *Physiognomic Crystallization* (fig. 37) and in *43* (fig. 42), i. e. the anchoring of straight linear forms – in this case, arms, a leg and forehead – to the painted ground. This intimate relationship between painting and drawing is a basic characteristic of Klee's art. Time and again he mediates between the two in an attempt not to allow the drawing to be isolated from the painting and the painting not to function simply as a background for the drawing. The strong graphic component in Klee's painting betrays a conception of the art fundamentally opposed to *peinture pure*, in which everything derives from painting alone. It would certainly be wrong-headed to view Klee principally as a graphic artist, whose painting consisted of no more than the backgrounds and colouring of his pictures. On the other hand, painting always meant drawing as well to him.

Considerably more serious-minded than the cheerful *Has Head, Hand, Foot and Heart* is the watercolour with the 'geometric' title *Semicircle in Relation to Angles* (fig. 55). This almost seems to be the answer to an art teacher's exercise like 'relate a semicircle to an angle'. Klee's solution is geometrically imprecise: the right-angle is not an exact one and the horizontal rectangle towards the bottom has come out at a slant. But above all, Klee has expanded the subject matter way beyond the scope of the exercise. He places the geometrical shapes within a close texture of small squares dabbed on in – not absolutely! – horizontal lines. Around 1930 Klee often made use of this pictorial structure, which recalls the Pointillism of the late nineteenth century. 'Divisionism' was his name for it. A further geometrical element appears within the 'divisionist' structuring – a triangle which, with no definite outline, exists solely by virtue of variations in the tonal gradations applied to the little squares. As a result, the picture seems multi-layered, spatial and suffused with light.

55 *Semicircle in Relation to Angles,* 1932

56 *View over the Plain*, 1932

One genealogy of modern colour-light painting would progress from Georges Seurat via Robert Delaunay to Klee, and it ought not to be forgotten that Delaunay, too, was initially influenced strongly by Pointillism. However, Klee was hardly interested in the theories of colour so essential to Seurat and Delaunay. He simply made use of a pictorial method which, although its possibilities were soon exhausted, helped him to create a number of masterful works.

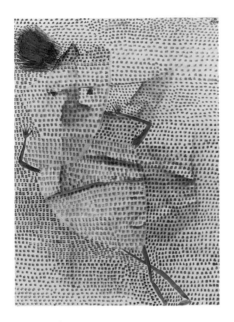

57 *Mask Louse*, 1931

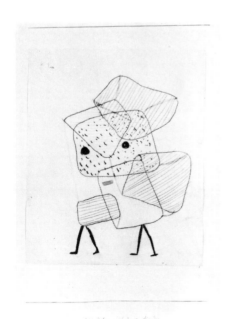

58 *Burdened Children*, 1930

View over the Plain (fig. 56) also belongs to the 'divisionist' pictures of 1932. Four lines travel sideways across the picture plane, frequently turning upwards or downwards. Overlappings occur and the areas thus engendered are differently marked with dots and short strokes. The "plain" exhibits various textures, as befits a landscape seen from above with its differing types of soil and agricultural cultivation. Another possible reading of the picture would see mountains or hills rising to project against the sky. This interpretation is apparently contradicted by the title which, since Klee was by now living and working in Düsseldorf, may allude to the Rhenish lowlands. Nothing points directly to a specific region; the picture simply represents a general opening out towards nature and landscape. The pictorial character, however, is quite specific, consisting of a 'puzzle' of irregular surface areas varying in texture from section to section. The plywood board on which the primed muslin is mounted grants the painting a harder appearance, more brittle and less airy, than the watercolour *Semicircle in Relation to Angles*.

The small *Mask Louse* (fig. 57) belongs to the same series. Varying colours and tonal gradations cause a transparent insect-like creature to emerge from amidst the 'divisionist' squares. It has human arms and legs and a patch of colour for a hat. Once again, Klee uses the same pictorial method for a work of light-hearted wit as he had for a strictly conceived one like *Semicircle in Relation to Angles* (fig. 55). The 'divisionist' phase did not last long, for Klee was incapable of raising any pictorial principle to the level of even a personal dogma. Besides, he had continued all the time to produce works of a quite different nature.

Burdened Children (fig. 58) is a case in point. Klee liked to load his figures with forms, as titles like *The Burdened One* (fig. 44), *Overburdened Devil* (fig. 60) and the present one show. In this coloured drawing the artist's working method is particularly transparent. He drew six overlapping forms, by and large rectangular but with rounded corners, and gave each of them a different texture. 'Like a child' he then added two eyes, a mouth and four legs. A moment of indecision came (are there one or two children?) and the impression arose of weight being carried, of 'overloading'. Here too, an element of Pointillism occurs in the child's face. A striking resemblance exists between the thin 'childish' legs and those in *Mask Louse*. These legs appear frequently in Klee's work.

Another drawing – *Repentance and Compassion* (fig. 59) – represents both a more diverting and a more frightening product of Klee's unceasing need to note down graphic ideas. Although they take no special account of pictorial principles, such drawings were prompted just as much by formal considerations as by a particular theme: Klee did not set out to draw scurrilous figures; rather, the drawing took on scurrilous forms as it progressed.

This procedure gave birth to a repentant animal with a human head, which is being consoled by a homunculus with an over-sized one. Graphic fantasy engendered not only these two figures, but also a self-contained play of forms in the rear part of the repentant animal. Similar sets of dissonant shapes, scarcely belonging together and simply placed next to one another, occur in many works from Klee's later years. Nevertheless, antecedents for this particular sheet obviously exist in such earlier works as the drawing *Joseph's Chastity Disturbs the Lower Regions* of 1913 (fig. 7).

59 *Repentance and Compassion,* 1932

60 *Overburdened Devil*, 1932

To turn to a painting is once again to find the anecdotal subordinated to a self-contained image. In *Overburdened Devil* (fig. 60) a wolf-like monster, with two drops issuing from its open mouth, one large eye and two pointed ears, stalks across the picture from left to right. The creature is in no way terrifying. Instead, the whole seems like a humorous masquerade, with two actors dressed up as a four-legged beast which therefore moves awkwardly across the stage. The stylization of the picture and its wealth of small-scale forms recall those Mexican hieroglyphics in which various written characters invoke demons. Here, the demonry is mere play.

Klee's move to Düsseldorf marks the beginning of a new period in his art. He starts using those large formats which were to prevail during the final decade of his creative life. His art appears less and less intimate as the imagery becomes increasingly expansive, the forms larger and more emblematic and the poetic element less prominent. Rune-like signs take the place of narrative. Anecdotal aspects decline in importance and the pictures become more 'abstract' – although not without exception and not as a matter of principle. This new simplicity and severity of artistic vocabulary is obviously connected with political events in Germany: the threatening upheaval, the Nazis' accession to power and the growing danger of a large-scale war. Dismissed from the Düsseldorf Academy in 1933, Klee moved to Berne at the end of that year. In 1935 he suffered the first signs of the illness which was to lead to his death in 1940. Thus, the fate of Europe and his own personal fate went hand in hand. Although to the last Klee was always ready to give vent to his humour – which nevertheless became increasingly mocking and bitter – his art acquires a grandeur and power of expression not previously associated with him.

The large painting *Garden after the Thunderstorm* (fig. 61) still belongs to 1932. It occupies an unusual position in Klee's oeuvre. Interlocking like the pieces of a puzzle, countless small forms lie side by side, filling the entire painting without any sense of tension and unrelated to any dominant features. Here too, a series of intertwining lines divides the surface into individual areas, to which the painter then added some representational 'ingredients', such as the shining red flower and the plant opening out at bottom centre. There are earthly and plant-like forms everywhere; a mound of earth breaks through the horizontal line separating the 'earth' from the 'sky', The colours lend the picture a strange atmosphere. Two sudden flashes of red recall the manner in which the drenched forms of nature shine brightly when lighted up by the sun after a storm – hence the title. Klee composed the picture like a mosaic or a piece of stained glass, yet without straight lines or right-angles: irregularity becomes the rule as the luxuriant garden falls into disorder after a heavy rainfall. Vegetative form as an analogy to natural vegetation is a basic motif of Klee's art.

Gardens also occur frequently in Klee's work. This may be accounted for by his habit of experiencing the cosmos on a

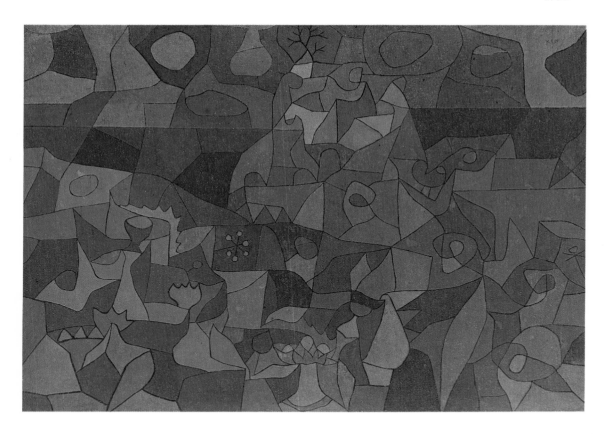

61 *Garden after the Thunderstorm*, 1932

microcosmic level. He prefers to reveal nature's grandeur in the smallest of gardens rather than encompassing it as a whole. The ordered shapeliness of gardens, as opposed to the wildness of unhampered growth, must have appealed to him. Less than twenty years separate *Garden after the Thunderstorm* from *Remembrance of a Garden* (fig. 9). The large painting 'throbs' less with natural life than the small watercolour: the forms have become more solid and the colours, no longer translucent, fill the firmly outlined forms without a hint of movement. Klee no longer follows quietly the voices of nature. Instead, he creates confidently in a pictorial language determined by a strong artistic will.

Cry for Help (1932; fig. 62) seems like a beacon warning against the fire spreading across the world in troubled times. The subject – a frightened girl shouting for help as she runs away from a fire – is itself serious, as is the artistic vocabulary. There is not a trace of caprice in the lines, no suggestion of delight in linear or anecdotal ideas. The lines – more strokes than lines – behave in just as terrified a manner as does the child. Expressive twitches of the pen hurriedly indicate the form of a girl running and screaming. The child does not even awaken child-like parody in the artist. It is surprising to encounter the Picassoesque motif of two eyes above, instead of beside, one another. Klee must indeed have been thinking of Picasso, who at this very time was depicting eyes thus. Otherwise, no affinity existed between the work of these two major artists of the century: the gap between Picasso's vitality and Klee's Romanticism was virtually insurmountable. This did not prevent Picasso from visiting Klee in Berne in 1937, five years after the creation of *Cry for Help*.

One detail – the dog tied to a wall on the left – does limit the gravity of the scene somewhat. Or does the dog rather increase its seriousness: is the girl running away from one scare straight into the next? Does the whole represent the hopelessness of fate or simply a girl's exaggerated fright of a small fire and a small dog? Do such interpretations credit the drawing with too much significance? Yet again, Klee leaves matters open; but the expressive seriousness of the work cannot be doubted.

The drawing's expressive character and its 'shorthand' draughtsmanship by no means exclude formal construction. The girl's torso consists of a rectangle, the collar of two triangles and the skirt of a parallelogram. A vertical line starts at the mouth and, in line with others, proceeds to divide the figure in two. And as so often in Klee's drawings and watercolours a further stabilizing element is provided by a straight line running across the top and bottom of the sheet. The title appears beneath the lower line.

62 *Cry for Help,* 1932

The pastel *Child Ph.* (1933; fig. 63) strikes one as a study for *Marked Man* of two years later (fig. 70). Yet it also recalls the previous year's *View over the Plain* (fig. 56). In both cases, a few lines curve slowly across the surface, intersecting to create separate areas. *Child Ph.* shows a child's head with large, knowing eyes and an anxious mouth. The draughtsmanship is seemingly childlike, but the childlike expression of great unconscious knowledge so far transcends all children's drawing that the contemporary charge of childishness is doubly hard to understand. Apart from the simple formal conception, Klee is here concerned with 'expression' – but not with the expressionism of a drawing like *Cry for Help*, in which emotion takes direct hold of the pen. Only rarely is Klee's art overtly emotional. As a rule, it employs all the means at its disposal quite consciously, with detachment and precision, even if the results may be full of expression.

The initial "Ph." gives the impression that *Child Ph.* is a portrait. A distinguishing mark, it recalls the way in which Klee had named a town square "L-Square" (fig. 31). He likes identifying and localizing, even if only in make-believe: *Child Ph.* is not actually a portrait. For Klee, the

63 *Child Ph.*, 1933

real and the seeming are not opposites; he may even have viewed reality as pure seeming, since it presents a finality for which no place exists in his way of thinking.

Klee painted the most diverse subjects at this time. It was probably a period of transition for him and certainly an unusually disturbed one. The reclining nude woman he painted in oil and crayon on a piece of jute remains almost invisible in the dark ground, as though he wished to avoid depicting a naked female body in a naturalistic manner. He called the picture *Patient* (fig. 64): a sick woman shrouded in the gloom of her – perhaps mental – disease. Klee had always been drawn to the flawed, to physical and mental imperfections, as his Symbolist etchings from the early years of the century or the *Portrait of Frau von Sinner* of 1906 (fig. 3) demonstrate. The skin in the latter picture, like that in *Patient,* consists more of lines than of genuine painting.

The irregularity of the torn-off jute and its frayed edges contribute much to *Patient.* Klee often sought such effects in his efforts to allow the picture support to play an active part in artistic results. He wanted to overcome the dualism of picture support and picture as well as that of painting technique and painting – the medium itself was always a source of artistic inspiration. Tearing off a piece of cloth freed him from the dictates of the right-angle, which could then be reestablished by the frame. Between picture and frame he provided – in *Patient* as in numerous other works – a stabilizing factor in the shape of a straight line, on which he wrote the date, work number and title.

64 *Patient,* 1933

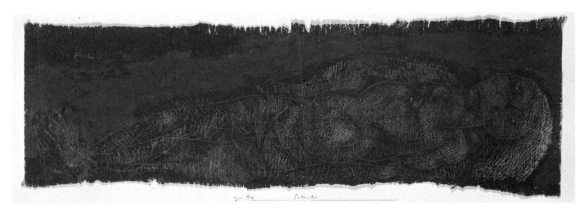

Thoughts in the Snow (fig. 65) was Klee's name for an almost square, white picture with a few lines and signs. What does the title mean? One can think of or about something – but thoughts can also wander. In this picture the artist's thoughts wander; he daydreams and draws away to himself. No particular theme guides the thinking, daydreaming and drawing. Klee submits to the will of his lines as they go in this or that direction, travel in straight lines or curves, or turn round abruptly and break off. These lines evoke the motions of a dream or of undirected thoughts. As in dreams, there are occasional points of repose, here marked by signs – a circle, half-moon, cross, comma, exclamation mark and short parallel lines. *Dream-like* is the title of a very similar drawing from the year 1930, in which the linear tracings of thought end in dense hatching. In both works the thoughts take shape on a white ground – they are *Thoughts in the Snow.*

In the mid-1920s the Surrealists coined the term *écriture automatique* to denote a pictorial method by which the unconscious expresses itself directly ("automatically") in the movements of the painter's or draughtsman's hand. *Thoughts in the Snow* fulfills Surrealist requirements in a surprisingly complete, if certainly unintentional, manner. Although the Surrealists valued Klee more for his fantastic subjects than for such pictorial procedures, the picture is not far removed from the paintings, some of them also primed in white, which Miró produced after 1925, with their 'abstract' lines, letters and various markings. One may well question if such works do, in fact, give expression to the unconscious. A style of the unconscious, with its 'wandering thoughts', on no account means that the artist acted unconsciously. Spontaneity and its control obviously work together; the lines are drawn and the signs set down with a high degree of artistic consciousness.

In contrast to other works of the period – for example, *Child Ph.* (fig. 63) – the areas produced by the intersecting lines of *Thoughts in the Snow* are of minimal importance. Everything concentrates on the lines, the white surface simply serving as a background. Surprisingly, Klee used watercolour to draw the lines and signs on the hard gesso priming of the tulle, as though not wanting to intrude upon the sleeping and dreaming with a more substantial medium. Another term introduced by the Surrealists, 'psychic automatism', describes best the state of mind – not the pictorial method – evoked in this quiet picture.

65 *Thoughts in the Snow,* 1933

The opulent forms of *Landscape near Pilamb* (fig. 66), interlocking everywhere and not especially rich in associations, recall those of *Garden after the Thunderstorm* (fig. 61). Yet it is a watercolour, and that underlines the plant-like organic nature of the shapes: watercolour is their sap and they drink their fill of it. Life flows through these living, flowering, developing organisms. One could hardly find a more complete demonstration of Klee's conception of nature as life, growth, movement and freedom than this sheet, which gives expression both to his closeness to and his distance from nature. He emphasized the distance by locating this piece of nature "near Pilamb", a mythological place of fairy-tales and dreams. Not of this earth, it is a realm where nature obeys the same laws of growth but where changed climatic conditions produce more fantastic forms. "On other planets," Klee said, "quite different forms may have arisen. Such mobility along nature's creative paths provides a good schooling in form. It is able to move the creator to his very roots and, himself mobile, he will see to it that his creative paths develop freely."

Mediation (1935; fig. 67) is one of Klee's large paintings. A comparable format would have been unthinkable a few years before, despite the fact that the picture's formal composition recalls such watercolours as *Atmospheric Group in Motion* (fig. 49) and *Exotic Sound* (fig. 51). Here too, the fluid transparent areas have an organic, or biomorphic, character. The interpenetration of three simple shapes produces a tangle of lines. Starting off on a journey which ends at their points of departure, the three lines are without beginning or end – a common feature with Klee. The slow circling movement stops nowhere as it traces the path of the artist's hand. The shapes encircle and penetrate one another, uniting to form a single structure. Four red eyes suggest something human, but not humans themselves. Colour emphasizes not the outlines of the forms but the areas produced by their overlapping. Amalgamation – "mediation" – thus takes place in such a way that the three individual shapes are barely recognizable as such. The colours also mediate between the picture support and the painting, since the delicate medium of watercolour allows the texture of the jute to have an active share in the final effect. For Klee, transparency always signified transcendence – transcendence with regard to a general state of being, as exemplified by analogy in any single picture. This natural philosophy also makes itself felt in his later work, though less often than before.

66 *Landscape near Pilamb, 1934*

67 *Mediation*, 1935

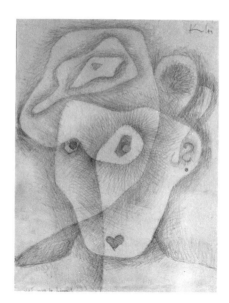

68 *Frau Brig,* 1934

69 *What's that she hears?,* 1934

Portrait-like drawings, such as *Frau Brig* (fig. 68) or *What's that she hears?* (fig. 69), sometimes appear on the fringe of Klee's artistic production. In *Frau Brig* – apparently a genuine portrait – loose pencil strokes produce an evenly modelled intimation of an individual face, while in the second drawing the intersection of curving lines once again gives rise to separate areas. The addition of two eyes – one pentagonal, the other sexagonal – and of a heart-shaped mouth resulted in a lady wearing a hat. Her faintly indignant expression finds words in the title and is strengthened by the question mark in place of an ear.

One always runs the risk of interpreting Klee's pictures simply as an illustration of their evocative titles. These offer a most helpful means of entering the artistic world of a picture, but no more than that: it is not sufficient to note that a picture conforms to the expectations aroused by its title. On the other hand, the title does often do justice to a work by leaving so much open to question – as in *Patient* (fig. 64). Another case in point is the painting with the ambivalent title *Marked Man* (1935; fig. 70). Ambivalence was a part of Klee's mode of thought. Of course, he "marked" the man when drawing him but, more significantly, the large earnest eyes, the sorrowful mouth and the discoloured skin show him to have been "marked" by fate.

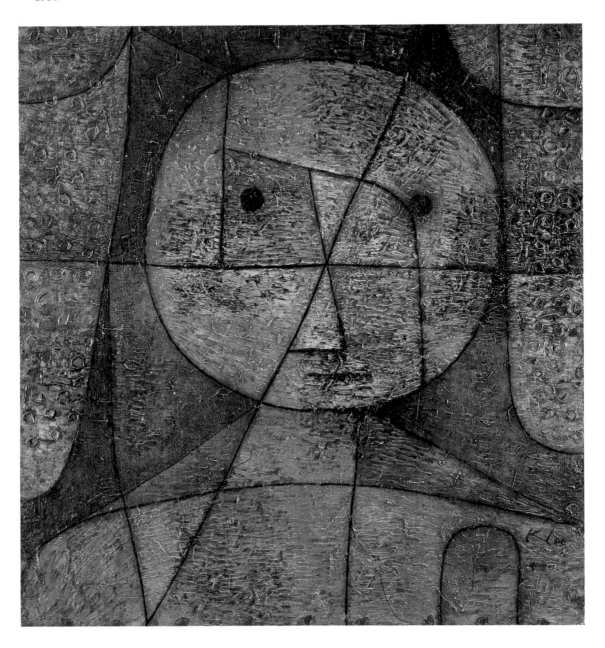

With curtains closing from above on either side, the figure faces the beholder as though on a stage or at a window. A dense, 'sickly' impasto covers the entire picture, stamping the figure with another of fate's scars. The emotional impact of the painting is immediate despite the strong articulation of such 'abstract' forms as a circular head and a few lines meeting at its centre. Incidentally, the comparable circular head of *Child Ph.* (fig. 63) had also been

70 *Marked Man,* 1935

divided into areas by intersecting lines and also possessed two earnest eyes and a mouth consisting of a thin line.

The picture, too, tells of Klee's detached attitude to 'painting pictures', of his avoidance of *peinture pure* and, more specifically, of oil painting. It is astonishing that he selected the medium of watercolour, normally reserved for work on paper, for a picture of this size. Apparently contradicted by the format and the rough texture of the support, the choice was certainly determined by the wish for transparency. Klee repeatedly departed from traditional modes of painting, without in the least wanting to appear 'original'. Oil painting did not satisfy him completely. He used it frequently, but often preferred other media and techniques, including such unusual ones as coloured paste, watercolour on canvas or spraying paint over stencils.

Although executed in oil, *Marked Man* does not present oil painting in the conventional sense of fluent brushwork. Instead, heavily primed gauze (mounted on cardboard) helps in the production of a surface treated so as to form a kind of coloured skin. Fifteen years earlier, at a time when he was discovering the medium of oils, Klee had created *Head with German Beard* (fig. 22). That was still painting, although the picture does hint at a rejection of *peinture pure,* especially in the interdependence of painting and drawing. In *Marked Man* not only has the drawing become more prominent, but painting itself has come to mean a material treatment of the surface, without, however, increasing either the planar effect or the materiality of the picture. In part, it is the painting technique which makes the figure seemed "marked".

In the year he painted this picture Klee suffered the first signs of his fatal illness. Without wishing to exaggerate the importance of this for the painting itself, it has to be pointed out that from now on Klee himself was a "marked man".

The watercolour drawing *Entering Figure* (fig. 71) shows a few lines drawn with a straightedge but broken so as to enliven their severity. An ochre oval with two eyes appears at the top of the sheet. This 'head' turns the rest of the drawing into a figure, which the artist apparently felt to be entering a room. Strange figures facing the beholder as though from a stage run like a leitmotiv through Klee's entire oeuvre, taking on the most varied forms imaginable. *Sgnarelle* of 1922 (fig. 28) or, closer still, the female acrobat in *Lions, Attention Please!* of 1923 (fig. 29) are forerunners of the fragile *Entering Figure*.

In *Group of Conifers* (fig. 72) numerous short strokes of the palette knife engendered a fleeting impression of nature. As so often, a painting technique motivated the picture, which then took on the aspect of a winter landscape of trees.

71 *Entering Figure*, 1935

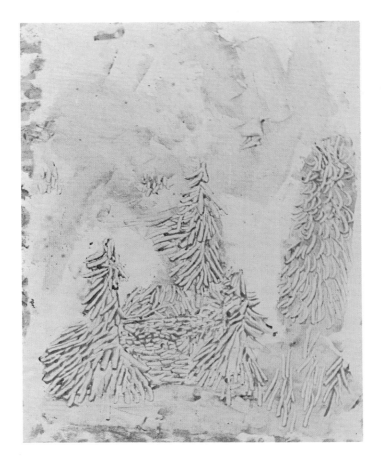

72 *Group of Conifers*, 1935

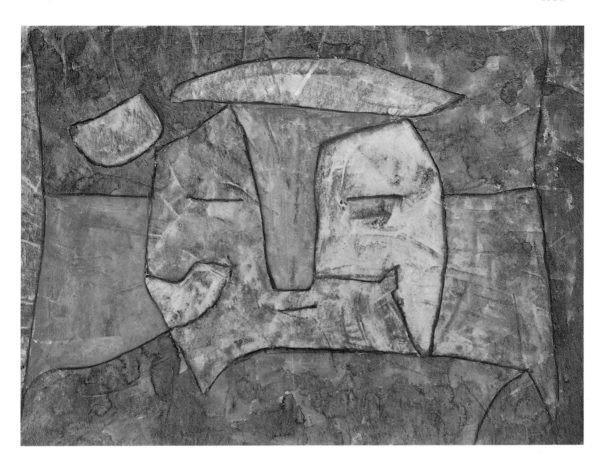

73 *St. Anthony after the Attack*, 1935

The formal arrangement of *St. Anthony after the Attack* (fig. 73) recalls *Marked Man* (fig. 70). Both pictures originated in 1935, at a time when human images were gaining in importance in Klee's art. The watercolour also depicts a marked man (scarred by an attack) but differs from the tragic *Marked Man* in possessing a quiet wit. Perhaps the title causes the picture to appear more humorous than Klee intended, for the formal means and the expression of spiritual exhaustion are without doubt capable of a serious interpretation. Klee himself would probably have objected to seeing humour and seriousness as irreconcilable opposites and he could quite easily have given even *Marked Man* a less earnest, more unequivocally parodistic title. His early Symbolist etchings from the beginning of the century already showed that his humour by no means ruled out seriousness and that his seriousness certainly included humour.

74 *Dancing Scene*, 1938

The brush drawing *Dancing Scene* (fig. 74) recalls the earlier *Cry for Help* (fig. 62), although it hardly matches the latter's expressive intensity. A few strokes conjure up three ballerinas, two of them small in the background, and a further dancer whose movement towards the right is underlined by three arrows. Klee places little value on dancing momentum. On the contrary, the main figure

dances most awkwardly past the beholder, her arms and long-fingered hands thrown up in the air. With her staring eyes she, like her partner, concentrates on the viewer and this interrupts the dancing motion. The two dancers in the background bear witness to Klee's way of thinking in terms of formal categories: their skirts consist of two semi-circles, one hanging from, the other standing on, a horizontal line drawn across the left-hand side of the sheet.

The Boulevard of the Abnormal Ones (fig. 75) is painted in coloured paste, a medium Klee often turned to in his later years. The impasto combines with the newspaper support to provide the artist with welcome material qualities. One confronts a curious procession of people turning towards the beholder as they pass by. The figures, an animal among them, are abstract formulae of lines and dots. Klee had been living in Switzerland for some time when he painted this picture, but even at this late stage he was often derided as not quite normal. Here, he transfers this ridicule to a group marching solemnly across the picture in top hats.

75 *The Boulevard of the Abnormal Ones,* 1938

Klee's 'late period' began when he was not yet sixty years old. Even today many people still miss what they think of as the 'real' Klee in these late works. He was certainly no longer the witty story-teller, the 'poetic' Klee of the cosmic visions of 1920 or the Klee of the richly peopled *theatrum mundi* of forms of the years thereafter. His painting became more grave and severe. On a superficial level it also became more 'abstract': bar-like lines and black signs became the main carriers of pictorial expression. This did not prevent the survival of basic characteristics or the continued use of many elements from his early years. Yet Klee's painting acquired a new quality. It presents itself in a more imposing manner, partly as a result of larger formats. It is less accessible to the beholder, less endearingly playful. More self-contained, it 'entertains' less and enchants less. Instead, it possesses a new urgency of statement.

One feature shared by early and late work is the more or less regular divison of the picture plane into squares. In his later years Klee preferred to compose his pictures with larger areas of colour. Either the areas abut peacefully or their edges are intensified by black bars scanning the entire surface. Sometimes the black signs possess a rhythm and content of their own, independently of the edges of the coloured areas. Klee's late works constantly remind one of stained glass windows and their leading. Despite his preference for coloured areas, either next to each other or overlapping, and for black signs, the artist also produced pictures of a completely different kind and, to the very last, continued to create humorous anecdotal works — especially drawings.

Signs are another constant factor in Klee's oeuvre. They changed character in his late period, however much such earlier works as *Necropolis* (fig. 52) may have anticipated this development. Of increased importance generally, they often even dominate a picture. Above all, their 'statements' acquired greater weight: they point more directly, if not more specifically, towards meanings. In may cases they seem like the letters of an unfamiliar alphabet; understandably, they have often been likened to hieroglyphs or runes.

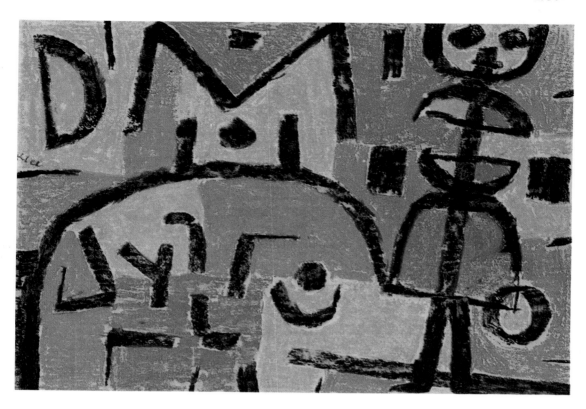

76 *Fate of a Child*, 1937

Fate of a Child (1937; fig. 76) is constructed from areas of colour. Pastel grants the surface of the picture and especially the thick black lines a certain softness. The gradations of blue increase the stained-glass effect but the black bars do not outline in the manner of leading. Travelling freely on the mosaic-like ground, they even adopt the shape of a girl carrying a basket or bag. With her large eyes, the child is – seemingly – painted the way children paint; she is certainly painted the way children are. The signs appear to be fragmented letters. Although indecipherable, they point to the unknown, to the unknown fate of a child – to fate as a whole. There exists a palpable relationship between the signs and the child, caused not least by the large 'M'. One may connect this with 'mother' without the artist requiring one to do so: free association represents a further constant factor in Klee's work. Justice is not done to his art by refusing to follow up associations and provide answers, even if these must remain in the form of a question.

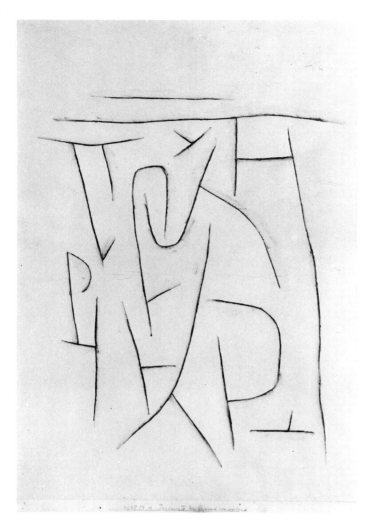

In *Fragments of a Region long since Past* (fig. 77), a drawing of exceptional size and beauty, the lines form neither figures or objects, nor, indeed, anything nameable. This 'abstract' work testifies to Klee's emblematic and increasingly broad pictorial vocabulary in the late 1930s. The lines travel across the paper calmly yet everywhere with the greatest spontaneity. Not for the first time in Klee's art they seem 'musical'. The signs come close to letters and one is tempted to see them as part of an alphabet so ancient as to be no longer intelligible. Klee's title points in this direction by setting the signs in an unknown area of time and space (in a "region long since past") and calling them "fragments" (possibly the relics of a vanished culture). Thus, Klee once again invokes deep historical layers and, with them, a deeper state of human knowledge. He does so with the

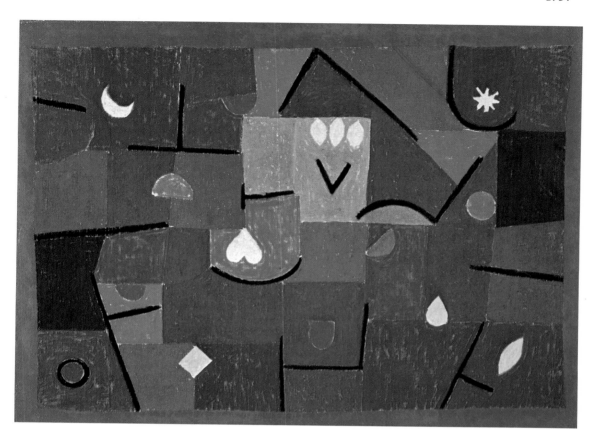

78 *Gems*, 1937

utmost economy. Nothing mystical, nothing amorphous, not even a fantastic element, is to be discovered. He invests a minimum of linear motion with a high degree of spirituality and invites the viewer to think about such remote things as a "region long since past".

Gems (fig. 78), a peaceful tapestry of coloured areas in a unified tonality, also exemplifies Klee's late pictorial form. The individual areas stand edge-to-edge as in stained glass, frequently bordered and separated by black lines. Various shapes are scattered over this 'patterned' surface – 'purely' formal ones, like circles, ovals and rectangles, as well as representational ones with emotional connotations, like the heart, moon and star. Characteristically, both abstract and representational forms possess equal pictorial value: being made of the same substance, they differ only in externals. Strewn over the surface texture, the shapes appear like gems in the earth. Klee still immerses himself in the "elemental realm" earth; his Romantic liking for the mysterious in nature has simply taken on another, in itself less Romantic, form.

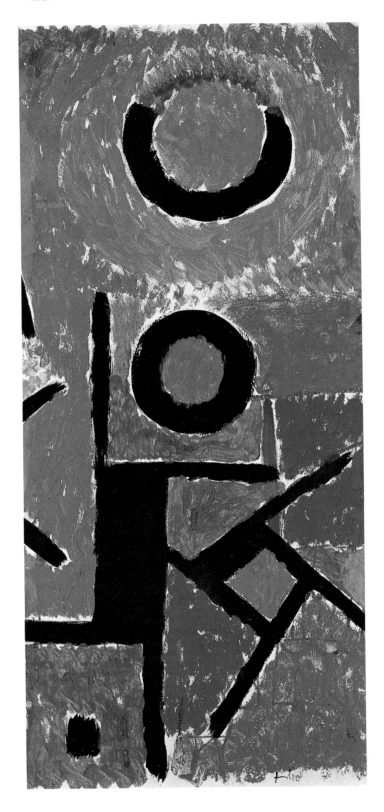

79 *Hot Message,* 1937

Since Klee's abstract signs are loaded with meaning one might describe them as bearers of messages. They point to a theme, and leave it at that. *Hot Message* (fig. 79) is the title of a small picture containing a few straight and circular signs. The title states explicitly that Klee conceived the signs not as abstract but as indicative of meaning. They carry a message, the content of which is, in the final analysis, 'just' the sum of the picture and all its characteristics.

Klee calls one of his watercolour drawings *Cross Imposing Order* (fig. 80). Disordered lines, signs and dots are organized into four sections by a large cross. A sheet like this makes clear how Klee's art became increasingly governed by the artist's conscious intentions. He no longer listened passively to the quiet voices of nature and, as a result, the pictures lost their medial and seismographical character. They were subjected more completely to the will of the artist. Brushstrokes refer to the personality which determined their form and their course. Although he never put his personality on display, Klee now released forces unknown in his earlier work. His physical suffering may well have forced this terse vocabulary upon him, but what matters is that in it, too, he found valid forms.

A variety of signs covers *Red Waistcoat* (fig. 81). All of them
– the straight, curved and angled lines, short or extended,
as well as the dots – are dark with light edges. As in many
pictures of this period, Klee lets two lines touch each other
in order to stabilize the diverging symbols. He achieves a
unified harmony by filling the shapes in between the signs
with a limited range of colours, as he had done in *Gems*
(fig. 78) and *Fate of a Child* (fig. 76). A staring face appears
above a reddish buttoned-up waistcoat at the top of the
picture and another one at the bottom. Two linear struc-
tures move like animals from left to right. Among the
other things the artist took from his store of forms and
scattered over the picture were a letter, an exclamation
mark and an anchor-like shape. The active motions of the
lines contrast with the passive repose of the coloured
ground yet they remain firmly embedded in it, like letters
carved in the stone of an ancient stele.

Typically, Klee is not content with setting down signs on a
surface but allows the one-dimensionality of the latter to
be disrupted by a pair of staring eyes. These are, so to
speak, the eyes of the picture, through which it makes
contact with the beholder. Front-on figures and eyes gaz-
ing out at the viewer while also appearing to look inwards
are motifs which run through Klee's entire oeuvre. Pre-
sented – or presenting themselves – in a quite specific
way, they introduce themselves directly to their opposite
number, the beholder. Klee's planar pictures always con-
tain an element of extroversion, as they consciously
address the viewer with an insistent request to carry on
looking. This singles out Klee from other painters of his
generation.

81 *Red Waistcoat*, 1938

Small pictures also exhibit the broad formal vocabulary of these later years – *Dangerous*, for example (fig. 82). As in *Red Waistcoat* (fig. 81) the dots and thick black lines have white edges and, again, two pairs of lines touch each other as though deliberately avoiding intersection. The lines do not cross one another and that, too, distinguishes these pictures from earlier ones. The signs are self-contained and free: Klee has ceased to follow the 'musicality' of lines. Scarcely lines at all, these dynamically energetic brushstrokes organize the picture both formally and expressively – messages from an artist who feels that at this late stage statements have to concentrate on essentials. Georg Schmidt, the author of a monograph on Klee, characterized this with the happy phrase "variations on the theme 'Final Stroke'".

Klee gave a drawing from this group of works the strange title *It's still struggling* (fig. 83), which presumably means that what is emerging still has to find its shape. The forms are not final, developed or balanced. Subject to no overall rhythm, they stand side by side in an oddly isolated fashion. This phenomenon was encountered in *Repentance and Compassion* of 1932 (fig. 59), where unrelated shapes came to form a curious group on the left. Such compositional indifference hardly existed in Klee's earlier work, but it frequently occurs in his late period. In this particular drawing one sees lines of varying thickness and a thin ribbon winding its way among the other forms for no apparent reason. A suggestion of female forms remains indecisive. The general impression is of a technical experiment – black tempera and paste on transparent paper –

83 *It's still struggling*, 1937

with no great artistic ambition. The drawing originated on the way towards a completion which was denied it – a drawing in which everything is "still struggling". Nevertheless, Klee signed it and gave it a title so, with its carefree vivacity, it takes its place among his late oeuvre of drawings.

Nothing was more foreign to Klee than glorification of the heroic, so the title *Heroic Roses* (fig. 84) comes as a surprise. Heroes do occur occasionally in his work, but are always taken down from their pedestals and made to look ridiculous. The present title echoes the dramatic pathos of the black signs and their motions. It is also surprising that Klee treated a plant motif in this way. The abrupt movement of the lines and the dynamism of the spirals and zigzags might recall roses and thorns, yet they contradict Klee's life-long preoccupation with the vegetative. Natural growth is not celebrated here; no sap flows through these forms and lines. The forms no longer 'live' as in nature, but rather oppose it, evoking human will combatting resistance rather than will-less nature. Even in this final phase of his art Klee's pictures seldom exhibited such a high degree of decisiveness and formative energy.

Single motifs can, once again, be traced back to earlier works. In the drawing *Plants in the Field* of 1921 (fig. 20), for example, plant forms also unrolled in spiral motions. Yet one senses how they are pushed upwards by the organic forces pulsing through them. Every line conveys growth, and the flat forms curl up without human will intervening. In *Heroic Roses,* on the other hand, nature has been deprived of its effect – and of its efficacy. The only thing reminiscent of it is the title. The painter acts instead of reacting.

A magnificent display of colour develops in between the almost violent forms which have taken hold of the picture. The procedure also differs from that of the many works in which Klee first created a coloured ground, often like an irregular mosaic, before beginning to draw. In *Heroic Roses* he drew the signs before filling the spaces in between with colour. Although the black lines dominate, the colour is of an exceptional richness. A similar opulence characterizes a large number of Klee's paintings from these years, providing a counterpoint to the new breadth of his formal vocabulary.

84 *Heroic Roses,* 1938

Lady and Fashion (fig. 85), one of this period's large-scale paintings, is more lyrical – indeed, more flower-like than the picture of roses. A few emblematic lines – or a few linear emblems – appear on a cloudy, fragrantly coloured ground. These signs are not static: they move in a leisurely manner, shaping into two forms in the process. The right-hand one seems to be a woman. The left-hand one may be a piece of hanging cloth but can also be read as a female figure. Forms and colours make up the picture, not a lady or fashion, although there is something feminine and something fashionable about them.

Once again an eye gazes out of the picture. It is fish-shaped, and that is typical of Klee – not just because fishes fascinated him and he often painted or drew them, but also because he in no way objected to an eye looking like a fish. Pictorial reality permits anything, including a fish in place of a human eye. Klee does not indicate whether it really is a fish or not. Leaving matters of interpretation open thus remained characteristic of him even in the for-mally conclusive works of his late period.

85 *Lady and Fashion,* 1938

For *Interim near Easter* (1938; fig. 86) Klee tore off an irregular piece of course-grained jute, mounted it on canvas and painted on it in the delicate medium of watercolour. Once again, he created a variety of abstract signs – simple and complicated; straight and curved; horizontal, vertical and diagonal. Lying on the surface like exotic hieroglyphs, they evoke familiar objects like snakes, faces and letters. The snake motif at top left occurs in a comparable form in many scripts of ancient Egypt. There can be no doubt that Klee was aware of this and that the picture recalls his visit to Egypt ten years previously.

This wholly lyrical painting conveys a sense of flowering, of something undecided which still has to come to fruition. This state of becoming is the impression referred to by the title – an image of a transitional period, the time before Easter. On the other hand, the forms are clear-cut and do not avoid the right-angle, however much the edges of the picture may deny it. These edges contribute much to the painting, offering a point of reference to the lines which organize it, lend it rhythm and fill it with significance.

As in *Heroic Roses* (fig. 84) the colours crowd in between the graphic signs. Yet here they are gentle and, as a result of the coloured 'aura' given the thin lines, more at one with the signs – soft lines and lyricism as against the strong contrasts and drama of *Heroic Roses*.

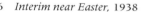

86 *Interim near Easter,* 1938

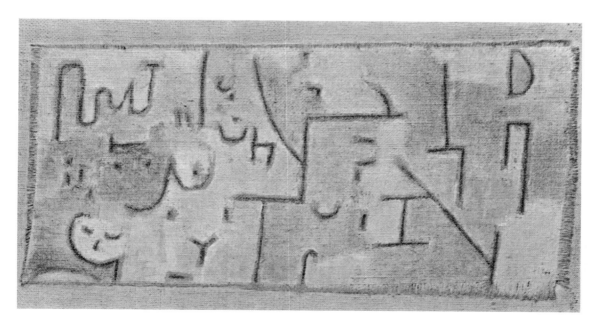

"Nature can afford to be extravagant in everything, but the artist must practise the utmost economy" Klee wrote at an early date. He adhered to this maxim all his life but in later years his formal means became even more sparing, so that he approached nature, too, with a reduced stock of forms. This occasionally gave rise to pictures close to nature, some of them – like *Deep in the Woods* of 1939 (fig. 87) – of an almost pantheistic Romanticism.

Consisting of nothing more than some relatively naturalistic leaves and a flower or fruit, all of which glow in a green lighter than that of the forest depths, the picture is yet an image of nature itself. The mysterious workings of nature fascinated Klee to the last, even if his later painting was shaped more by his own will than by natural energies.

In the terse imagery of these years plants still open and close. Formation still comes before form, as Klee had once put it, and nature continues to be conceived as genesis: everything moves, lives and shapes itself dynamically. In addition, *Deep in the Woods* also evinces longing for nature. A highly romantic – and very German – picture, it is nevertheless completely unsentimental.

Sentimentality exists in Klee's art only as an object of irony. 'Moods' (of the forest depths, for instance) occur but rarely in his work, at the most in such earlier pictures as *Cosmic Composition* (fig. 13). Significantly, Klee took exception to the heartfelt affection for animals conveyed by the pictures of his friend Franz Marc. He himself professed to greater detachment, in accordance with his conviction that in relation to the totality of the world "the visible is but one isolated example". In the same passage of his diary – written as early as 1919! – he declared: "People used to depict things seen on earth, things they enjoyed seeing or would have liked to see. Today, the relativity of visible things is being revealed." He maintained this reserved attitude towards visible reality, and thus also towards natural objects, through all periods of his art. In pictures like *Deep in the Woods*, however, the degree of detachment appears somewhat reduced.

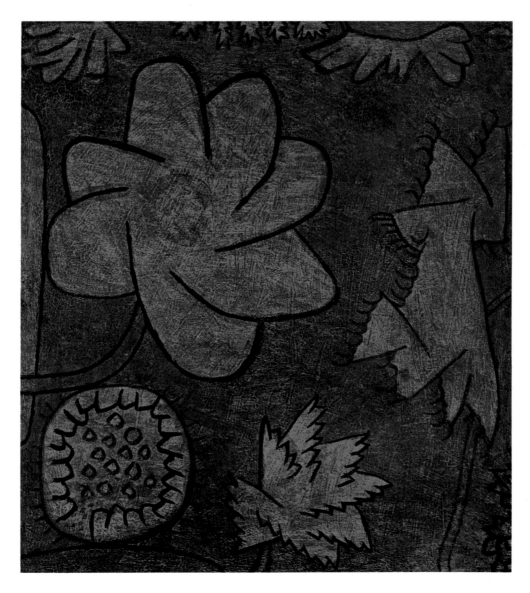

87 *Deep in the Woods*, 1939

The same applies to *Rose Bush* (fig. 88). As in *Group of Conifers* of 1935 (fig. 72) an impression of nature arises directly from the painting gestures. To the end Klee's technical experiments enticed him into creating forms and structures. With just two colours and a few irregular brush-strokes he gives life to a sheet of paper and watches as something takes shape almost of its own accord. Casual works, not governed by a specific intention, thus still occur in Klee's late period. A comparison between the modest *Rose Bush* and *Heroic Roses* (fig. 84), both from 1938, demonstrates how wide a range of possibilities remained for depicting a single subject.

In the large-scale drawing *Blooming* (1937; fig. 89) Klee again treated a botanical, or floral, theme, this time in green pastel on brown wrapping paper. Returning to the fantastic plant drawings of 1921 (figs. 19, 20) one appreciates the full extent of the transformation Klee's art had undergone during a period of less than twenty years. The fundamental characteristics of nature have become unimportant. At most, it is the sheet itself which blooms; the plants, inasmuch as they can be identified as such, bend and curve, but do not flower. Jagged right-angled bars would have been inconceivable in Klee's early depictions of plants. Nature's organic cohesion has been abolished: the signs lie side by side like fragments. Missing is the sense of growth: the plants are not rooted in the earth, nor do they draw their nourishment from it and pass on the sap to the leaves and flowers — all distinctive features of Klee's earlier plants. Like botanical remains, these schematic fragments cover the sheet with apparent arbitrariness, more open and spacious at the top, closer together at the bottom. Order is barely perceptible. This recalls the slightly erratic distribution of forms in *It's still struggling* (fig. 83), also dating from 1937. Nothing seems to fit quite, and a unifying formal principle hardly exists, let alone a 'composition'. That the picture does nevertheless possess shape results from the energies and tensions governing it. An art like this does not go out to meet the beholder. It neither entertains or amuses, nor is it amiable — as were so many of Klee's earlier pictures, especially the drawings. One senses an increased seriousness in Klee's life, as in his art. And one senses that this drawing was not only drawn, but also lived through: more powerful, uncompromising and restless than usual, it gives direct expression to his life and experience. Thus it acquires a tragic aura — which the title strengthens, since blooming is scarcely in evidence.

On the other hand, Klee still offered lighter fare occasionally during these last years. Although he was no longer the intimate artist of the past and although his style — and frequently the pictures themselves — had become large-scale, he still continued to paint cheerfully intimate works — for example, *The Dragon Car at the Aerodrome* (fig. 90). Its technique of watercolour on jute — almost a contradiction in terms — is one Klee returned to from time to time. The subject seems simple, but remains puzzling all the same. An absurd three-wheeled car takes on a slightly animal appearance at the front. Its elongated, creaturely form

88 *Rose Bush*, 1938

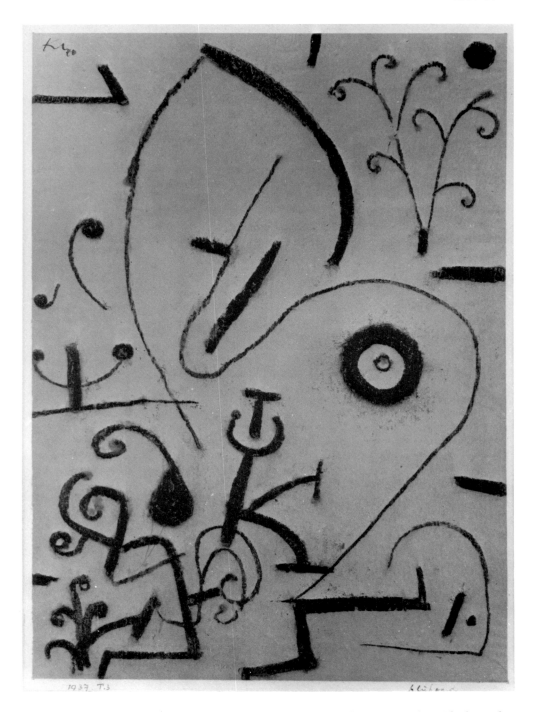

89 *Blooming*, 1937

may have given rise to the 'dragon' in the title but, the German word being identical in both cases, this could also refer to what looks like a kite issuing sideways on the left. There is no aerodrome, yet the structure might be an airport vehicle of the artist's imagination. Klee still liked to

tell stories, and he does so here with a single line, whose various caprices end at their starting point (the three wheels are the only additions) — a pictorial method characteristic of the artist, as is the use of coarse torn-off jute and its permeation of the delicate watercolour.

From Klee's last years comes a large figure painting with a pompous title, *Omphalo-centric Lecture*, which makes ironic use of classical education (fig. 91). A female figure enters the lecture theatre between curtains hanging down on either side, as they had in *Marked Man* of 1935 (fig. 70). Her heart-shaped mouth recalls the one in the parodistic female portrait *What's that she hears?* of 1934 (fig. 69). The lecturer is, therefore, not to be taken too seriously. Other features underline this: the wing-shaped sides of her face, the extreme tapering of the left arm of an otherwise rather stout lady and, above all, the preciously delicate hand in which she holds a ring burning with inner fire in the position of her navel. The ancient Greeks spoke of the 'navel *[omphalos]* of the world'. Thus, the lecturer is obviously holding forth on the nature of all things, something which Klee, who all his life had occupied himself with the nature of all things in his art, here holds up to ridicule. He never lost his sense of humour.

Klee's art spanned both the grave and the humorous. In *Marked Man* (fig. 70) the figure also appears from between curtains and gazes at the beholder with two circular eyes. But he possesses the infinite sadness of a clown, whereas the "omphalo-centric" lady can only be understood as a grotesque product of Klee's mockery.

90 *The Dragon Car at the Aerodrome*, 1939

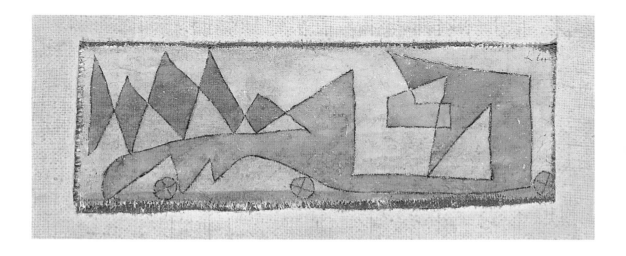

91 *Omphalo-centric Lecture,* 1939

To finish with, another grave picture, one originating from 1939, a time when Klee repeatedly depicted angels and demons (fig. 92). On a ground covered completely with black he drew a figure in white body colour. It carries a kind of shield bearing a red cross, so that one thinks for a moment of crusaders. The figure seems to hide behind the shield. Yet the title – which is not written on the sheet itself – indicates a more humorous content. In Klee's catalogue of his works the picture appears as *The Insured Parcel*. Accordingly, the object would be a large package, which the figure – or are there two? – is pressing close to its body with its large right hand. However, this banal subject matter apparently contradicts the solemn gravity of the picture.

The lines travel across the surface in expansive motions, enveloping parts of the figure in a certain pathos and never intersecting. That the drawing appears in the 'negative' – white on black – heightens the linear precision and the force of the lines. The stance of the figure, its hugging of the 'parcel' and its half-hidden face peering out from behind acquire great intensity of expression through a minimum of simple lines. At this time Klee produced a never-ending series of (mostly pencil) drawings, all executed in a similar manner with large-scale forms locked together in gentle curves and developing into the most diverse creatures and scenes. Sheet for sheet, he drew with sovereign ease. The results were sometimes serious and sometimes humorous to the point of carica-ture, the title subsequently emphasizing one or the other. In these drawings, which are governed by a certain graphic pathos, Klee often seems to have shunned sombre interpretations, employing the title to tip the balance in favour of wit. Angels and demons appear time and again but the titles usually refer to them with gentle or acrid humour. The title *The Insured Parcel* may, therefore, repre-sent a deliberate attempt to render the drawing less momentous. But momentous it is. On the basis of other works from this period one is tempted to interpret the figure as a demonic being, but Klee may have had only a theatrical masquerade in mind. In any case, he would have objected to a hard and fast distinction between seri-ousness and humour. If his art as a whole deserves the appellation *theatrum mundi,* then here it is as though one of its actors appears before the public for the last time.

92 *The Insured Parcel,* 1939

List of Illustrations

1

Boy in Fur Coat (Knabe im Pelz), 1909
Pen and Indian ink and wash on Ingres paper mounted on board, 9 $^1/_4$ x 8 $^7/_8$ in. (23.5 x 22.5 cm.)
Signed and dated l. r.: "Klee 1909 4"
Inscribed on board l. l. and r.: "Knabe im Pelz 1909 4"
Klee cat. no. 1909, 4
Inv. 54

2

Houses on the Edge of the Wood (Häuser an der Waldecke), 1908
Watercolour on glass, 11 x 12 $^3/_{16}$ in. (28 x 31 cm.)
Signed and dated l. l.: "Paul Klee 1908"
Not in Klee cat.
Inv. 1

3

Portrait of Frau von Sinner (Bildnis der Frau von Sinner), 1906
Watercolour and pen and ink on glass partially engraved, 20 $^1/_4$ x 15 $^9/_{16}$ in. (51.3 x 39.5 cm.)
Signed and dated u. r.: "Klee. 1906."
Klee cat. no. 1906, 26
Inv. 89

4

Oriental City (Orientalische Stadt), 1912
Pen and black Indian ink and wash on yellow linen paper mounted on board, 4 $^7/_8$ x 10 $^1/_{16}$ in.
(12.4 x 15.6 cm.)
Signed u. r.: "Klee"
Inscribed on board l. l.: "Orientalische Stadt 1912 133"
Klee cat. no. 1912, 133
Inv. 56

5

Lake Thun seen from Burning Forest (Blick vom Waldbrand auf den Thuner See), 1909
Pen and black Indian ink on linen paper mounted on board, 4 $^{15}/_{16}$ x 10 $^7/_{16}$ in. (12.6 x 26.5 cm.)
Inscribed on board l. l. and r.: "Waldbrand üb. d. Thun-See 1909 31"
Klee cat. no. 1909, 31
Inv. 55

6

Yellow House in the Fields (Gelbes Haus in Feldern), 1912
Pen and ink and watercolour on Fabriano paper mounted on board, 6 $^5/_{16}$ x 7 $^{15}/_{16}$ in. (16 x 20.2 cm.)
Signed l. r.: "Klee"
Inscribed on board l. l.: "Gelbes Haus in Feldern 1912 69"
Klee cat. no. 1912, 69
Inv. 2

7

Joseph's Chastity Disturbs the Lower Regions (Josephs Keuschheit erregt den Unmut der trüben Regionen), 1913
Pen and black Indian ink on French Ingres paper mounted on board, 7 $^3/_{16}$ x 5 $^7/_8$ in. (18.2 x 15 cm.)
Signed l. r.: "Klee"
Inscribed on board below: "Josephs Keuschheit erregt den Unmut der trüben Regionen 1913 25"
Klee cat. no. 1913, 25
Inv. 57

8

Red and White Domes (Rote und weisse Kuppeln), 1914
Watercolour and body colour on Japan vellum mounted on board, 5 $^3/_4$ x 5 $^3/_8$ in. (14.6 x 13.7 cm.)
Signed u. l.: "Klee"
Inscribed on board l. l.: "Rote u. weisse Kuppeln 1914.45."
Klee cat. no. 1914, 45
Inv. 1014

9

Remembrance of a Garden (Erinnerung an einen Garten), 1914
Watercolour on linen paper mounted on board, 9 $^7/_8$ x 8 $^7/_{16}$ in. (25.2 x 21.5 cm.)
Signed l. r.: "Klee"
Inscribed on board: "1914.7. Erinnerung an einen Garten"
Klee cat. no. 1914, 7
Donated in 1979 by VEBA AG, Düsseldorf
Inv. 1289

10
City with Graduated Fountain (*Stadt mit stufenför-migem Springbrunnen*), 1915
Pen and ink on Fabriano paper mounted on board,
3³/₄ x 8¹/₄ in. (9.6 x 20.7 cm.)
Signed c. l.: "Klee"
Inscribed on board l. l.: "1915 133"
Klee cat. no. 1915, 133
Inv. 58

11
Brown Triangle Striving at Right-angles (*Braunes, rechtwinklig strebendes Dreieck*), 1915
Watercolour on chalk-primed Ingres paper mounted on board, 8⁷/₁₆ x 5¹/₄ in. (21.4 x 13.3 cm.)
Signed u. l.: "Klee"
Inscribed on board l. l.: "1915 71"
Klee cat. no. 1915, 71
Inv. 3

12
With the Dragon's Bite (*Mit dem Drachenbiss*), 1919
Pen and black Indian ink on satin paper mounted on board, 10¹/₄ x 6³/₄ in. (26.1 x 17.1 cm.)
Signed c. r.: "Klee"
Inscribed on board l. l.: "1919 27"
Klee cat. no. 1919, 27
Inv. 59

13
Cosmic Composition (*Kosmische Composition*), 1919
Oil on panel, 18⁷/₈ x 16³/₄ in. (48 x 41 cm.)
Inscribed on label pasted onto reverse: "1919 16[5]
Kosmische Composition Klee"
Klee cat. no. 1919, 165
Inv. 4

14
Camel in a Rhythmic Wooded Landscape (*Kamel in rhythmischer Baumlandschaft*), 1920
Oil on chalk-primed gauze mounted on board,
18⁷/₈ x 16⁹/₁₆ in. (48 x 42 cm.)
Unfinished colour study on reverse
Signed and dated l. r.: "Klee 1920, 43"
Klee cat. no. 1920, 43
Inv. 1030

15
Feather Plant (*Federpflanze*), 1919
Oil and pen and ink on thin canvas (aircraft canvas) mounted on cardboard with painted borders,
16⁵/₁₆ x 12³/₈ in. (41.5 x 31.5 cm.)
Signed and dated l. r.: "Klee 1919.180". Inscribed on label pasted onto reverse: "1919.180. Federpflanze Klee"
Klee cat. no. 1919, 180
Inv. 5

16
Ride (*Ritt*), 1920
Pen and violet ink on writing paper mounted on board, 7³/₈ x 11³/₁₆ in. (18.7 x 28.5 cm.)
Signed u. l.: "Klee"
Inscribed on board l. c. l.: "1920 144 (Ritt)"
Klee cat. no. 1920, 144
Inv. 63

17
Remembrance of an Island Adventure (*Erinnerung an ein insulares Abenteuer*), 1920
Pen and violet ink on writing paper mounted on board, 7³/₈ x 11³/₁₆ in. (18.7 x 28.5 cm.)
Signed l. r.: "Klee"
Inscribed on board l. r.: "1920 95"
Klee cat. no. 1920, 95
Inv. 61

18
Industrial Landscape (*Industrielle Landschaft*), 1920
Pencil on writing paper mounted on board,
4¹⁵/₁₆ x 11³/₁₆ in. (12.5 x 28.5 cm.)
Signed u. r.: "Klee". Inscribed on board l. l.:
"1920.58. Industrielle Landschaft"
Klee cat. no. 1920, 58
Inv. 60

19
Strange Plants (*Seltsame Pflanzen*), 1921
Pencil on writing paper mounted on board,
8⁷/₈ x 11¹/₈ in. (22.6 x 28.3 cm.)
Signed l. r.: "Klee"
Inscribed on board l. c.: "1921/203 Seltsame Pflanzen"
Klee cat. no. 1921, 203
Inv. 67

20
Plants in the Field I (*Pflanzen auf dem Acker I*), 1921
Pen and black Indian ink on yellowish linen paper mounted on board, 7³/₈ x 11¹/₁₆ (18.8 x 28.2 cm.)
Signed l. r.: "Klee"
Inscribed on board l. c.: "1921/160 Pflanzen auf dem Acker I"
Klee cat. no. 1921, 160
Inv. 65

21
Maenadic Terror (*maenadischer Schreck*), 1920
Pen and violet ink on writing paper mounted on board, 8⁹/₁₆ x 11¹/₈ in. (21.8 x 28.3 cm.)
Signed l. r.: "Klee"
Inscribed on board l. c.: "1920.141. maenadischer Schreck"
Klee cat. no. 1920, 141
Inv. 62

22

Head with German Beard (*Kopf mit deutscher Bart-tracht*), 1920
Oil and pen and ink on thin paper mounted on panel, 12 13/$_{16}$ x 11 3/$_{16}$ in. (32.5 x 28.5 cm.)
Signed and dated l. r.: "Klee 1920.22." Inscribed on reverse: "1920./22. Kopf mit deutsch Barttracht Klee"
Klee cat. no. 1920, 22
Inv. 6

23

The Equilibrist above the Swamp (*Die Equilibristin über dem Sumpf*), 1921
Pen and black Indian ink on drawing paper mounted on board, 11 5/$_{8}$ x 7 1/$_{16}$ in. (29.5 x 18 cm.)
Signed l. c.: "Klee". Inscribed on board l. l.: "1921/59 Die Equilibristin über dem Sumpf"
Klee cat. no. 1921, 59
Inv. 64

24

The Impudent Animal (*Das schamlose Tier*), 1920
Oil transfer drawing with watercolour on chalk-primed brown paper mounted on board,
7 3/$_{16}$ x 10 1/$_{4}$ in. (18.3 x 26 cm.)
Signed u. r.: "Klee"
Inscribed on board l. l.: "1920/115 Das schamlose Tier"
Klee cat. no. 1920, 115
Inv. 7

25

Having Bats in the Belfry (*hat einen Vogel*), 1921
Pen and black Indian ink on writing paper mounted on board, 10 3/$_{4}$ x 4 3/$_{16}$ in. (27.3 x 10.6 cm.)
Signed u. l.: "Klee"
Inscribed on board below: "1921 221 hat einen Vogel"
Klee cat. no. 1921, 221
Inv. 68

26

Ecstatic Priestess (*verzückte Priesterin*), 1921
Pen and ink on yellowish German Ingres paper mounted on board, 11 13/$_{16}$ x 9 in. (30.1 x 22.9 cm.)
Signed l. r.: "Klee". Inscribed on board below: "1921/201 verzückte Priesterin"
Klee cat. no. 1921, 201
Inv. 66

27

Glass Figures (*Glasfiguren*), 1923
Pen and black Indian ink on writing paper mounted on board, 11 15/$_{16}$ x 8 13/$_{16}$ in. (28.8 x 22.4 cm.)
Signed u. l.: "1923 5/12 Glasfiguren Klee"
Inscribed on board l. l. and r.: "1923 199 Glasfiguren"
Klee cat. no. 1923, 199
Inv. 69

28

Sganarelle, 1922
Oil transfer drawing and watercolour on French Ingres paper mounted on board with u. and l. borders painted, 19 1/$_{4}$ x 15 3/$_{8}$ in. (49 x 39 cm.)
Signed l. r.: "Klee Sganarelle"
Klee cat. no. 1922, 25
Inv. 8

29

Lions, Attention Please! (*Löwen, man beachte sie!*), 1923
Oil transfer drawing and watercolour on French Ingres paper mounted on board with coloured borders, 14 3/$_{16}$ x 20 1/$_{8}$ in. (36 x 51.2 cm.)
Signed r. c.: "Klee"
Inscribed on board l. l. and r.: "1923 155 Löwen, man beachte sie!"
Klee cat. no. 1923, 155
Inv. 11

30

Sequel to a Drawing of 1919 (*Nach einer Zeichnung aus dem Jahr 1919*), 1923
Oil transfer drawing and watercolour on thin printing paper mounted on board, 8 1/$_{16}$ x 10 13/$_{16}$ in. (20.5 x 27.5 cm.)
Signed u. r.: "Klee"
Inscribed on board l. l. and r.: "1923 94. Nach einer Zeichnung aus dem Jahr 1919"
Klee cat. no. 1923, 94
Inv. 10

31

The L-Square Under Construction (*Der L-Platz im Bau*), 1923
Watercolour and body colour on chalk-primed newspaper mounted on board, 15 9/$_{16}$ x 20 1/$_{8}$ in.
(39.5 x 51.7 cm.)
Signed c. r.: "Klee"
Inscribed on board l. l. and r.: "1923/11 Der L-Platz im Bau"
Klee cat. no. 1923, 11
Inv. 9

32

South American Landscape (with two Llamas)
(*Südamerikanische Landschaft [mit zwei Lamas]*), 1924
Pen and violet ink on writing paper mounted on board, 8 7/$_{8}$ x 11 3/$_{16}$ in. (22.6 x 28.5 cm.)
Signed u. r.: "Südamerikanische Landschaft 1924 3 12. Klee"
Inscribed on board l. c.: "1924.51."
Klee cat. no. 1924, 51
Inv. 71

33

Stallion Taming (*Hengstzähmung*), 1926
Pen and black Indian ink on yellow German Ingres
paper mounted on board, 6 1/8 x 5 3/8 in.
(15.6 x 13.6 cm.)
Signed l. l.: "Kl."
Inscribed u. l.: "26212"
Inscribed on board l. c.: "1926. N. 4. Hengstzähmung"
Klee cat. no. 1926, N 4 (44)

34

Rotation,1924
Pen and blue-black ink on writing paper mounted on
board, 5 1/16 x 8 15/16 in. (12.9 x 22.7 cm.)
Signed l. r.: "Klee"
Inscribed on board l. c.: "1924 30 Rotation"
Klee cat. no. 1924, 30
Inv. 70

35

Overculture of Dynamoradiolars 1 (*Überkultur von
Dynamoradiolaren 1*), 1926
Pen and black Indian ink on Ingres paper mounted on
board, 9 1/16 x 12 1/8 in. (23 x 30.8 cm.)
Signed l. l.: "Klee"
Inscribed on board l. l. and r.: "1926 D. 3. Überkultur
von Dynamoradiolaren 1"
Klee cat. no. 1926, D 3 (133)
Inv. 73

36

Study of Light and Dark (Easel Lamp) (*Helldunkel-
Studie [Staffeleilampe]*), 1924
Watercolour on German Ingres paper mounted on
board, 12 x 9 1/4 in. (30.5 x 23.5 cm.)
Signed l. r.: "Klee"
Inscribed on board l. c.: 1924.23. Helldunkel-Studie
(Staffeleilampe)"
Klee cat. no. 1924, 23
Inv. 13

37

Physiognomic Crystallization (*Physiognomische Kri-
stallisation*), 1924
Oil on muslin mounted on board with narrow colou-
red borders, 16 7/16 x 20 1/4 in. (41.8 x 51.4 cm.)
Signed l. l.: "Klee 1924/15 Physiognomische Kristalli-
sation"
Klee cat. no. 1924, 15
Inv. 12

38

Monsieur Pearlswine (*monsieur Perlenschwein*), 1925
Watercolour sprayed over stencils on Japanese plate
paper mounted on board, 20 1/4 x 13 in.
(51.5 x 35.5 cm.)

Signed l. r.: "Klee"
Inscribed on board l. l. und r.: "1925 'W. 3.' monsieur
Perlenschwein"
Klee cat. no. 1925, W3 (223)
Inv. 14

39

Reconstruction, 1926
Oil on muslin primed with oil cement and mounted on
hardboard, 14 5/16 x 15 1/2 in. (36.3 x 39.3 cm.)
Signed and dated l. r.: "Klee 1926 T. null"
Klee cat. no. 1926, T0 (190)
Inv. 15

40

Rio on Elba (*Rio auf Elba*), 1926
Pen and ink on German Ingres paper mounted on
board, 11 1/8 x 18 3/8 in. (28.2 x 46.7 cm.)
Signed u. r.: "Klee"
Inscribed l. r.: "Rio 26 9 12"
Inscribed on board l. c.: "1926 X 10 Rio auf Elba"
Klee cat. no. 1926, X 10 (240)
Inv. 74

41

Little Week-end House (*Kleines Sonntagshaus*), 1928
Coloured paste on cardboard on wooden frame,
9 1/16 x 13 3/4 in. (23 x 35 cm.)
Signed and dated l. r.: "Klee 1928p7"
Klee cat. no. 1928, P7 (67)
Inv. 18

42

43, 1928
Watercolour on gesso-primed gauze in wooden frame,
14 3/16 x 12 13/16 in. (36 x 32.5 cm.)
Klee cat. no. 1928, E5 (145)
Inv. 19

43

Black Prince (*schwarzer Fürst [Prinz]*), 1927
Oil on canvas primed in black with white tempera
underpainting and mounted on wood, 13 x 11 7/16
(33 x 29 cm.)
Signed and dated u. l.: "Klee 1927 L4"
Klee cat. no. 1927, L4 (24)
Inv. 16

44

The Burdened One (*der Beladene*), 1929
Oil on gesso-primed jute mounted on plywood,
26 3/8 x 19 11/16 in. (67 x 50 cm.)
Signed l. r.: "Klee"
Klee cat. no. X 3 (233)
Inv. 20

45

Fireworks *(Feuerwerk)*, 1930
Watercolour on paste-primed scrap paper pasted on
board and mounted on hardboard, 8 $^5/_{16}$ x 13 $^1/_8$ in.
(21.1 x 33.3 cm.)
Signed l. l.: "Klee". Inscribed on reverse on
section of board: "1930 5. Feuerwerk"
Klee cat. no. 1930, 5
Inv. 22

46

Many coloured Lightning *(bunter Blitz)*, 1927
Oil on thin canvas pasted on cardboard and mounted
on duckboard, 19 $^{11}/_{16}$ x 13 $^3/_8$ in. (50 x 34 cm.)
Signed l. l.: "Klee"
Klee cat. no. 1927, J1 (181)
Inv. 17

47

Hanging Lamps *(Hänge-leuchter)*, 1927
Pen and black Indian ink on German Ingres paper
mounted on board, 12 x 18 $^1/_4$ in. (30.5 x 46.4 cm.)
Signed l. r.: "Klee"
Inscribed on board l. c.: "1927 N. 7. Hänge-leuchter"
Klee cat. no. 1927, N7 (47)
Inv. 75

48

In the Air above the Water *(in der Luft über dem
Wasser)*, 1928
Pen and black Indian ink on German Ingres paper
mounted on board, 17 $^{15}/_{16}$ x 12 in. (45.5 x 30.5 cm.)
Signed u. r.: "Klee 28/1/12". Inscribed on board l. c.:
"1928.L.1. in der Luft über dem Wasser"
Klee cat. no. 1928, L1 (21)
Inv. 76

49

Atmospheric Group in Motion *(atmosphaerische
Gruppe in Bewegung)*, 1929
Watercolour and pen and ink on German Ingres paper
mounted on grey board, 9 $^1/_{16}$ x 12 $^3/_{16}$ in. (23 x 31 cm.)
Signed l. l.: "Klee"
Inscribed on board l. c.: "1929.OE.6 atmosphaerische
Gruppe in Bewegung"
Klee cat. no. 1929, OE 6 (276)
Inv. 21

50

The Elated *(die Beschwingten)*, 1930
Pen and black Indian ink on writing paper mounted on
board, 11 $^1/_4$ x 8 $^3/_4$ in. (28.5 x 22.3 cm.)
Signed l. l.: "Klee"
Inscribed on board l. c.: "1930 qu 3. die Beschwingten"
Klee cat. no. 1930, Q3 (73)
Inv. 77

51

Exotic Sound *(exotische Klang)*, 1930
Watercolour and pen and ink on German Ingres paper
mounted on board, 18 $^1/_2$ x 24 $^3/_8$ in. (47 x 62 cm.)
Signed u. l.. .."Klee"
Inscribed on board l. l. and r.: "1930 L 8 exotischer
Klang"
Klee cat. no. 1930, L8 (28)
Inv. 23

52

Necropolis *(Nekropolis)*, 1930
Thick coloured paste applied with palette knife to
wrapping paper sized in red and mounted on card-
board, 19 $^{11}/_{16}$ x 14 in. (50.5 x 35.5 cm.)
Signed l. r.: "Klee"
Klee cat. no. 1930, 07 (57)
Inv. 24

53

Staging *(Regie)*, 1930
Watercolour and pen and ink on chalk-primed Ger-
man Ingres paper mounted on board, 11 $^5/_8$ x 18 $^1/_2$ in.
(29.5 x 47 cm.)
Signed l. r.: "Klee"
Inscribed on board l. l. and r.: „1930 E 1 Regie S. Cl."
Klee cat. no. 1930, E1 (201)
Inv. 25

54

Has Head, Hand, Foot and Heart *(hat Kopf, Hand,
Fuss und Herz)*, 1930
Watercolour and pen and ink on cotton pasted on
board mounted on hardboard, 16 $^5/_{16}$ x 11 $^7/_{16}$ in.
(41.4 x 29 cm.)
Signed u. l.: "Klee"
Inscribed on reverse on section of board: "1930.S.4 hat
Kopf, Hand, Fuss und Herz"
Klee cat. no. 1930, S4 (214)
Inv. 26

55

Semicircle in Relation to Angles *(Halbkreis zu Wink-
ligem)*, 1932
Watercolour and body colour on Italian Ingres paper
mounted on board, 18 $^7/_8$ x 11 $^{13}/_{16}$ in. (48 x 30 cm.)
Signed l. l.: "Klee"
Inscribed on board l. c.: "1932.5. Halbkreis zu Wink-
ligem"
Klee cat. no. 1932, 5
Inv. 28

56

View over the Plain (*Blick in die Ebene*), 1932
Oil on primed muslin mounted on plywood,
22⁷/₁₆ x 25³/₈ in. (57 x 64.5 cm.)
Signed l. r.: "Klee". Inscribed on reverse:
"1932 X 10 'Blick in die Ebene' Klee"
Klee cat. no. 1932, X 10 (270)
Inv. 30

57

Mask Louse (*Maske Laus*), 1931
Watercolour on scrap paper mounted on board with
coloured borders, 14³/₁₆ x 10⁷/₁₆ in. (36 x 26.5 cm.)
Signed u. r.: "Klee"
Inscribed on board l. c.: "1931 X.4. Maske Laus"
Klee cat. no. 1931, X4 (264)
Inv. 27

58

Burdened Children (*beladene Kinder*), 1930
Coloured pencil on white satin paper mounted on
board, 11³/₁₆ x 8¹¹/₁₆ in. (28.5 x 22 cm.)
Signed u. l.: "Klee"
Inscribed on board l. c.: „1930.U.8 beladene Kinder"
Klee cat. no. 1930, U8 (108)
Inv. 78

59

Repentance and Compassion (*Reue und Mitleid*),
1932
Pen and black Indian ink on yellow French Ingres
paper mounted on board, 9⁵/₈ x 12³/₈ in.
(24.5 x 31.5 cm.)
Signed l. r.: "Klee"
Inscribed on board l. c.: "1932 T 18 Reue und Mitleid"
Klee cat. no. 1932, T 18 (198)
Inv. 80

60

Overburdened Devil (*überladener Teufel*), 1932
Watercolour and body colour on French Ingres paper
sized with casein and mounted on board,
12³/₈ x 13³/₈ in. (31.5 x 34 cm.)
Signed u. l.:"Klee". Inscribed on board l. c.:
"1932 V.20. überladener Teufel"
Klee cat. no. 1932, V 20 (240)
Inv. 29

61

Garden after the Thunderstorm (*Garten nach dem
Gewitter*), 1932
Oil on canvas, 29¹/₂ x 41³/₄ in. (75 x 106 cm.)
Signed u. r.: "Klee"
Klee cat. no. 1932, X 17 (277)
Inv. 31

62

Cry for Help (*Hilferuf*), 1932
Brush and black Indian ink on Italian Ingres paper
mounted on board, 18⁷/₈ x 17¹/₈ in. (48 x 43.5 cm.)
Signed u. l.: "Klee"
Inscribed on board l. c.: "1932 qu 10 Hilferuf"
Klee cat. no. 1932, Q 10 (130)
Inv. 79

63

Child Ph. (*Kind Ph.*), 1933
Pastel on scrap paper primed in white and mounted on
board, 8¹/₄ x 13 in. (21 x 33 cm.)
Signed l. r.: "Klee"
Inscribed on board l. l. and r.: "1933 H.9.Kind Ph."
Klee cat. no. 1933, H9 (449)
Inv. 33

64

Patient (*Patientin*), 1933
Oil and crayon on primed jute mounted on board,
7¹/₁₆ x 20⁷/₈ in. (18 x 53 cm.)
Signed u. l.: "Klee"
Inscribed on board l. c.: "1933 H 19 Patientin"
Klee cat. no. 1933, H 19 (459)
Inv. 34

65

Thoughts in the Snow (*Gedanken bei Schnee*), 1933
Watercolour on gesso-primed tulle mounted on board,
17¹⁵/₁₆ x 18⁵/₁₆ in. (45.5 x 46.5 cm.)
Inscribed on reverse: "1933 L 12 Gedanken bei
Schnee"
Klee cat. no. 1933, L 12 (32)
Inv. 32

66

Landscape near Pilamb (*Landschaft bei Pilamb*), 1934
Watercolour and pen and ink on Ingres paper moun-
ted on board, 25³/₁₆ x 19 in. (64 x 48.3 cm.)
Signed l. l.: "Klee"
Inscribed on reverse of board: "1934 K 3 Landschaft bei
Pilamb"
Klee cat. no. 1934, K3 (23)
Inv. 35

67

Mediation (*Vermittlung*), 1935
Waxed watercolour on gesso-primed jute, 47¹/₄ x 43⁵/₁₆ in.
(120 x 110 cm.)
Signed u. l.: "Klee"
Inscribed on stretcher: "1935 p 16 'Vermittlung' Klee"
Klee cat. no. 1935, P 16 (116)
Inv. 38

68

Frau Brig, 1934
Pencil on transparent paper mounted on board,
16 9/16 x 11 3/4 in. (42 x 29.8 cm.)
Signed u. r.: "Klee"
Inscribed on board l. c.: "1934 qu 13 Frau Brig"
Klee cat. no. 1934, Q 13 (133)
Inv. 82

69

What's that she hears? *(Was muss sie hören!)*, 1934
Pencil on writing paper mounted on board,
11 13/16 x 8 5/16 in. (30 x 21.1 cm.)
Signed u. r.: "Klee". Inscribed on board l. l. and r.:
„1934 M 7 Was muß sie hören!"
Klee cat. no. 1934, M7 (67)
Inv. 81

70

Marked Man *(Gezeichneter)*, 1935
Oil and watercolour on thickly primed gauze mounted
on cardboard, 12 x 10 13/16 in. (30.5 x 27.5 cm.)
Signed l. r.: "Klee"
Inscribed on stretcher: "1935 R 6. 'Gezeichneter'. Klee"
Klee cat. no. 1935, R6 (146)
Inv. 39

71

Entering Figure *(ein-tretende Figur)*, 1935
Watercolour drawing on Italian Ingres paper mounted
on board, 19 1/8 x 11 13/16 in. (48.5 x 30 cm.)
Signed l. l.: "Klee". Inscribed on board l. l. and r.
"1935 M 16 ein-tretende Figur"
Klee cat. no. 1935, M 16 (76)
Inv. 83

72

Group of Conifers *(Coniferen-Gruppe)*, 1935
Coloured paste on Canson Ingres paper mounted on
board, 11 7/8 x 9 7/16 in. (30.2 x 24 cm.)
Signed u. l.: "Klee". Inscribed on board l. l. and r.:
"1935 13 Coniferen-Gruppe"
Klee cat. no. 1935, 13
Inv. 36

73

St. Anthony after the Attack *(St. Anton nach dem
Anfall)*, 1935
Watercolour on blackened chalk-primed Monopol pa-
per mounted on cardboard, 15 1/16 x 19 5/8 in.
(38.3 x 49.8 cm.)
Signed u. l.: "Klee"
Klee cat. no. 1935, M4 (64)
Inv. 37

74

Dancing Scene *(Tanz-Scene)*, 1938
Black watercolour drawing on Zanders paper mounted
on board, 15 9/16 x 11 3/16 in. (39.5 x 28.5 cm.)
Signed u. l.: "Klee"
Inscribed on board l. c.: "1938 G 14 Tanz-Scene"
Klee cat. no. 1938, G 14 (94)
Inv. 88

75

The Boulevard of the Abnormal Ones *(der Boule-
vard der Abnormen)*, 1938
Thick coloured paste on newspaper mounted on
board, 12 13/16 x 19 1/8 in. (32.5 x 48.5 cm.)
Signed u. r.: "Klee"
Inscribed on board l. l. and r.: "1938 E 6 der Boulevard
der Abnormen"
Klee cat. no. 1938, E6 (46)
Inv. 43

76

Fate of a Child *(Schicksal eines Kindes)*, 1937
Pastel on wrapping paper mounted on board,
13 3/4 x 19 11/16 in. (35 x 50 cm.)
Signed c. l.: "Klee"
Inscribed on board l. l. and r.: "1937 S. 20 Schicksal
eines Kindes"
Klee cat. no. 1937, S 20 (180)
Inv. 40

77

Fragments of a Region long since Past *(Fragmente
der Gegend von weiland)*, 1937
Charcoal and paste on Fabriano paper mounted on
board, 25 5/8 x 18 1/2 in. (65 x 47 cm.)
Signed u. r.: "Klee"
Inscribed on board l. c.: "1937 M 10 Fragmente der
Gegend von weiland"
Klee cat. no. 1937, M 10 (70)
Inv. 84

78

Gems *(Kleinode)*, 1937
Pastel on white cotton mounted on jute with coloured
borders, 22 7/16 x 29 15/16 in. (57 x 76 cm.)
Signed u. l.: "Klee"
Inscribed on stretcher: "1937 U 14. 'Kleinode' Klee"
Klee cat. no. 1937, U 14 (214)
Inv. 41

79

Hot Message (*heisse Botschaft*), 1937
Tempera paste on Fabriano paper pasted to board and mounted on hardboard, 19 1/8 x 8 11/16 in. (48.5 x 22 cm.)
Signed l. r.: "Klee". Inscribed on reverse of board: "1937. U 20. heisse Botschaft"
Klee cat. no. 1937, U 20 (220)
Inv. 42

80

Cross Imposing Order (*ordnendes Kreuz*), 1937
Watercolour and paste on writing paper mounted on board, 8 1/4 x 11 11/16 in. (21 x 29.7 cm.)
Signed c. r.: "Klee". Inscribed on board l. l. and r.: "1937 U 3 ordnendes Kreuz"
Klee cat. no. 1937, U 3 (203)
Inv. 86

81

Red Waistcoat (*rote Weste*), 1938
Waxed coloured paste on jute with cotton strips above and below and mounted on plywood,
25 5/8 x 16 15/16 in. (65 x 43 cm.)
Signed u. r.: "Klee". Inscribed on reverse of cotton strips: "1938.K.3. 'rote Weste' Klee"
Klee cat. no. 1938, K3 (143)
Inv. 47

82

Dangerous (*Gefährliches*), 1938
Oil on cotton stretched over cardboard, 11 x 23 5/16 in. (28 x 59.2 cm.)
Signed l. l.: "Klee"
Inscribed on stretcher: "1938.J.4. 'Gefährliches' Klee"
Klee cat. no. 1938, J4 (124)
Inv. 45

83

It's still struggling (*es ringt noch*), 1937
Black tempera and paste on transparent paper mounted on board, 16 7/16 x 11 9/16 in. (41.8 x 29.3 cm.)
Signed u. r.: "Klee"
Inscribed on board l. c.: "1937 W 16 es ringt noch"
Klee cat. no. 1937, W 16 (256)
Inv. 87

84

Heroic Roses (*heroische Rosen*), 1938
Oil on primed jute, 26 3/4 x 20 1/2 in. (68 x 52 cm.)
Signed u. l.: "Klee". Inscribed on stretcher: "1938 J 19. 'heroische Rosen' Klee"
Klee cat. no. 1938, J 19 (139)
Inv. 46

85

Lady and Fashion (*Dame und Mode*), 1938
Oil on jute primed in oil with palette knife, 27 9/16 x 39 3/8 in. (70 x 100 cm.)
Inscribed on stretcher: "1938.K 6. 'Dame und Mode' Klee"
Klee cat. no. 1938, K6 (146)
Inv. 48

86

Interim near Easter (*Zwischenzeit gegen Ostern*), 1938
Watercolour on jute primed in chalk and paste and mounted on canvas, 12 13/16 x 26 3/16 in. (32.5 x 66.5 cm.)
Signed l. r.: "Klee". Inscribed on reverse: "1938 V 2 Zwischenzeit gegen Ostern"
Klee cat. no. 1938, V2 (342)
Inv. 49

87

Deep in the Woods (*tief im Wald*), 1939
Dye and watercolour on oil-primed canvas mounted on canvas, 19 11/16 x 16 15/16 in. (50 x 43 cm.)
Signed l. r.: "Klee". Inscribed on stretcher: "1939 CC 14 'tief im Wald' Klee"
Klee cat. no. 1939, CC 14 (554)
Inv. 52

88

Rose Bush (*Rosenstrauch*), 1938
Thick coloured paste on writing paper mounted on board, 11 x 7 in. (28 x 17.8 cm.)
Signed u. l.: "Klee"
Inscribed on board l. c.: "1938 G 20. Rosenstrauch"
Klee cat. no. 1938, G 20 (100)
Inv. 44

89

Blooming (*blühend*), 1937
Blue-green pastel on wrapping paper mounted on board, 19 9/16 x 13 11/16 in. (49.7 x 34.8 cm.)
Signed u. l.: "Klee"
Inscribed on board l. l. and r.: "1937.T. 3 blühend"
Klee cat. no. 1937, T3 (183)
Inv. 85

90

The Dragon Car at the Aerodrome (*der Drachenwagen am Flugplatz*), 1939
Watercolour on jute primed in chalk and paste mounted on canvas, 5 15/16 x 16 5/16 in. (15 x 41.5 cm.)
Signed u. r.: "Klee"
Inscribed on reverse: "der Drachenwagen 39/501 am Flugplatz 1939 AA 1"
Klee cat. no. 1939, AA 1 (501)
Inv. 51

91
Omphalo-centric Lecture (*omphalo-centrischer Vortrag*), 1939
Coloured paste on silk mounted on jute,
27$^9/_{16}$ x 19$^7/_8$ in. (70 x 50.5 cm.)
Signed c. r.: "Klee". Inscribed on stretcher:
"1939 KK 10 'omphalo-centrischer Vortrag' Klee"
Klee cat. no. 1939, KK 10 (690)
Inv. 53

92
The Insured Parcel (*Das Wert-paket*), 1939
Body colour on sized paper mounted on board with
coloured borders, 19$^7/_{16}$ x 14$^3/_8$ in. (49.3 x 36.5 cm.)
Signed u. r.: "Klee"
Klee cat. no. 1939, UU 18 (858)
Inv. 50

DATE DUE

JUN 0 7 1987		
MAY 0 6 1988		
May 24 1988		
JUN 6 1989		
NOV 2 0 1990		
JUN 1992		
MAY 2 6 1992		
JUN 0 1 1994		
MAY 2 5 1997		
WITHDRAWN		